peaceful places
Portland

103 Tranquil Sites in the

Rose City and Beyond

by Paul Gerald

MENASHA RIDGE PRESS
www.menasharidge.com

Peaceful Places: Portland

Cover design by Scott McGrew
Text design by Annie Long
Cartography by Steve Jones
Interior and cover photos by Paul Gerald unless otherwise noted
Cover photo: Crystal Springs Rhododendron Garden offers 10 acres of tranquility; see page 42.

CATALOGING-IN-PUBLICATION DATA AVAILABLE FROM THE LIBRARY OF CONGRESS

ISBN: 978-0-89732-938-5

Menasha Ridge Press
P.O. Box 43673
Birmingham, Alabama 35243
menasharidge.com

Disclaimer

Seclusion can be part of the charm of a peaceful place. Likewise, in some locations, the best time to visit is early morning, sunset, or even in the evening, when few other people are around. Please maintain awareness of your surroundings and practice caution at every destination described in this book, just as you would when venturing to any isolated or unfamiliar location. Please also note that prices, hours, public-transportation routes, and other information can change over time—so check online, call ahead, or write for confirmation when making your travel plans. Every effort has been made to ensure the accuracy of the information in this book, and its contents are believed to be correct at the time of printing. Nevertheless, the publisher accepts no responsibility for errors or omissions, for information that may change after publication, or for the consequences of relying on such information. Assessments of sites are based on the author's own experience; therefore, descriptions given in this guide necessarily contain an element of subjective opinion, which may not reflect the publisher's opinion or dictate a reader's own experience on another occasion.

contents

peaceful places alphanumerically

three paths to 103 peaceful places

*I*n *Peaceful Places: Portland,* Paul Gerald serves up 103 locales for a few hours of quiet time in the greater metro area and farther afield. To make it easy for you to find an entry that suits your mood and desired neighborhood or type of place, we've organized the sites in three different ways:

the path ALPHANUMERICALLY

Beginning on page 1, each entry unfolds in the main text in alphabetical order and is numbered in sequence. That number travels with that entry throughout the book—in the Peaceful Places Alphanumerically guide (see pages iii–vi), in the Peaceful Places by Category guide (described in the next section and shown on pages x–xiii), in the Peaceful Places by Area guide (described on page viii and shown on pages xiv–xvii), and on the maps (pages xviii–xxv).

the path BY CATEGORY

The Peaceful Places by Category guide (see pages x–xiii) organizes the sites into 12 different groups, as listed below. The full text for each destination also includes its category at the top of that individual entry. In many cases it was difficult to classify a place, as it might be a historic site in an outdoor habitat with a scenic vista that feels like a spiritual enclave that's an urban surprise where you can take an enchanting walk! But we've tagged each site as it seems most fitting for the focus of the author's description.

Day Trips & Overnights	Outdoor Habitats	Scenic Vistas
Enchanting Walks	Parks & Gardens	Shops & Services
Historic Sites	Quiet Tables	Spiritual Enclaves
Museums & Galleries	Reading Rooms	Urban Surprises

the path **BY AREA**

The Peaceful Places by Area guide (see pages xiv–xvii) and the maps (see pages xviii–xxv) locate sites according to the following eight geographic divisions:

Central Portland (MAP 1)

Includes Downtown, the Pearl District, Old Town, and Riverplace.

North Portland (MAP 2)

Includes Boise, Delta Park, Hayden Island, and St. Johns.

Northeast Portland (MAP 3)

Includes Alberta Arts/Concordia, Cully, the Columbia Corridor, Irvington, Kerns, the Lloyd Center District, Rose City Park, and Roseway.

Southeast Portland (MAP 4)

Includes Belmont, Buckman, Division/Clinton, Eastmoreland, Hawthorne, Lents, Milwaukie, Midway, Mount Tabor, Oregon City, Sellwood, Sunnyside, and Woodstock.

Southwest Portland (MAP 5)

Includes Bridlemile, Collins View, Corbett–Lair Hill, Goose Hollow, Hillsdale, Johns Landing, Multnomah Village, Sylvan, West Hills, and West Linn.

Northwest Portland (MAP 6)

Includes the Alphabet District, Forest Park, Hillside, Nob Hill, the Outer Pearl District, and West Hills.

Outer Northwest Portland (MAP 7)

Includes Sauvie Island.

Farther Afield (MAP 8)

Oregon: Includes Arch Cape, Beaverton, Carlton, the Columbia River Gorge, Corbett,

Detroit, Dundee, Gervais, Hood River, Lafayette, Lincoln City, Mount Hood National Forest, Seaside, Sherwood, Sublimity, Tillamook, Troutdale, Wilsonville, and Zigzag. **Washington State:** Includes Carson, Ilwaco, Stevenson, Vancouver, and Washougal.

PEACEFULNESS RATINGS

Preceding the main text for each profile, listed information notes the entry's category and area. This capsule information also includes the author's rating for the site, on a scale of one to three stars, as follows:

✪✪✪ Heavenly anytime

✪✪ Almost always sublime

✪ Tranquil if visited as described in the entry—during times of day, week, season, and so on—and possibly to be avoided at other times

ESSENTIALS

At the end of each entry, you'll find the destination's full address, phone number, website address, any fees for entry (or a range of prices for menu items or other expenses), hours, and public-transportation choices. For those using GPS units, zip codes are included with street addresses. Where no street addresses exist, we've included driving directions (or websites listing them) and/or GPS coordinates. Hours and prices are subject to change, so call ahead to verify.

Regarding public transportation: "n/a" (not applicable) denotes destinations not reachable or easily accessible using such services. And as all Portland and other urban dwellers know, public-transportation schedules and routes are subject to change. The routes and connections provided are up-to-date at press time, but please check the appropriate websites to be sure you have the latest information for your own journeys.

Throughout Portland, your leading choices for public transportation are **MAX Light Rail,** the **Portland Streetcar,** and **TriMet Buses.** For more information, visit **trimet.org.**

—*The Publisher*

peaceful places by category

DAY TRIPS & OVERNIGHTS

ENCHANTING WALKS

HISTORIC SITES

PARKS & GARDENS *(continued)*

QUIET TABLES

READING ROOMS

SCENIC VISTAS

peaceful places by area

CENTRAL PORTLAND (Map 1)

NORTH PORTLAND (Map 2)

NORTHEAST PORTLAND (Map 3)

SOUTHEAST PORTLAND (Map 4)

SOUTHWEST PORTLAND (Map 5)

NORTHWEST PORTLAND (Map 6)

OUTER NORTHWEST PORTLAND (Map 7)

FARTHER AFIELD (Map 8)

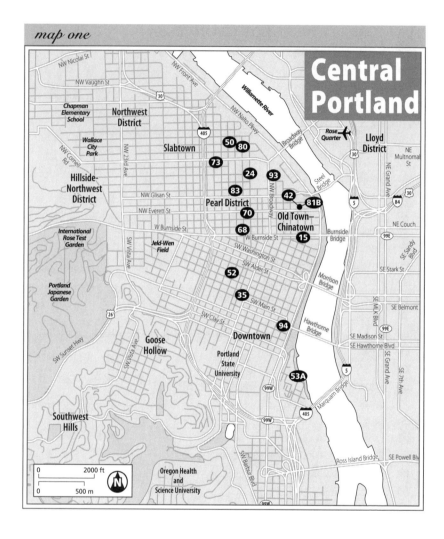

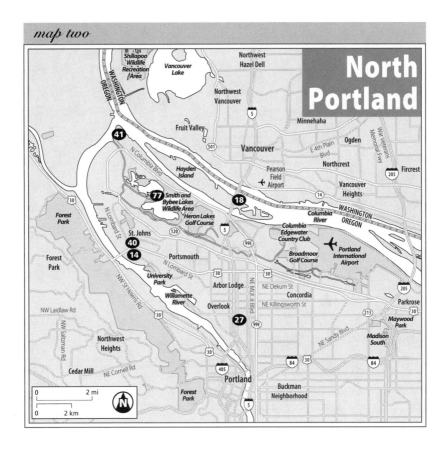

map two

North Portland

Shillapoo Wildlife Recreation Area
WASHINGTON
OREGON
Vancouver Lake
Northwest Hazel Dell
Northwest Vancouver
5
Fruit Valley
501
Minnehaha
Ogden
War Veterans Memorial Fwy
41
Vancouver
E 4th Plain Blvd
Northcrest
Fircrest
205
N Columbia Blvd
Hayden Island
Pearson Field Airport
Vancouver Heights
30
Forest Park
77 Smith and Bybee Lakes Wildlife Area
18
14
WASHINGTON OREGON
Columbia River
Heron Lakes Golf Course
St. Johns
120
5
Columbia Edgewater Country Club
Portland International Airport
Forest Park
40
14
Portsmouth
99E
Broadmoor Golf Course
205
N Lombard St
University Park
N Lombard St
Arbor Lodge
30
30
NE Dekum St
Concordia
Parkrose
N St Helens Rd
Willamette River
Overlook
NE Killingsworth St
213
30
Maywood Park
NW Laidlaw Rd
27
99E
Madison South
NW Saltzman Rd
Northwest Heights
NE MLK Jr Blvd
NE Sandy Blvd
NW Cornell Rd
30
405
84
30
84
Cedar Mill
NE Cornell Rd
Forest Park
Portland
Buckman Neighborhood

0 2 mi
0 2 km
N
5

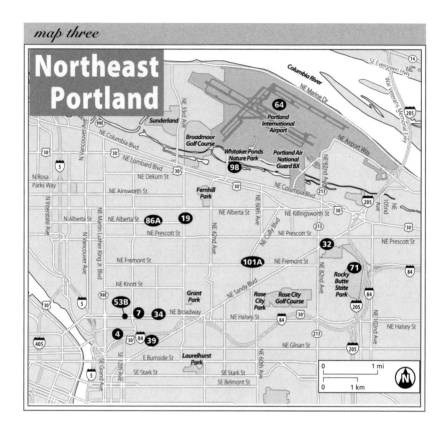

map three

Northeast Portland

Columbia River

SE Evergreen Hwy

NE Marine Dr

Sunderland

NE 33rd Ave

Broadmoor Golf Course

Whitaker Ponds Nature Park

98

Portland International Airport

64

Portland Air National Guard BX

NE Airport Way

War Veterans Memorial Fwy

NE Vancouver Ave

99E

NE Columbia Blvd

NE Lombard Blvd

NE Dekum St

NE Columbia Blvd

NE 82nd Ave

NE 105nd Ave

Fernhill Park

N Rosa Parks Way

NE Ainsworth St

NE Martin Luther King Jr Blvd

N Alberta St NE Alberta St

86A **19**

NE Prescott St

N Vancouver Ave

NE 42nd Ave

NE Alberta St

NE 60th Ave

NE Killingsworth St

NE Prescott St

32

NE Prescott St

N Interstate Ave

NE Fremont St

101A NE Fremont St

NE Knott St

Grant Park

NE Sandy Blvd

Rose City Park

Rose City Golf Course

Rocky Butte State Park

71

99E

53B

7 **34** NE Broadway

NE Halsey St

4

39

E Burnside St

Laurelhurst Park

SE Stark St

SE 12th Ave

SE Grand Ave

SE Stark St

SE Belmont St

NE Glisan St

NE 60th Ave

NE 102nd Ave NE Halsey St

0 1 mi

0 1 km

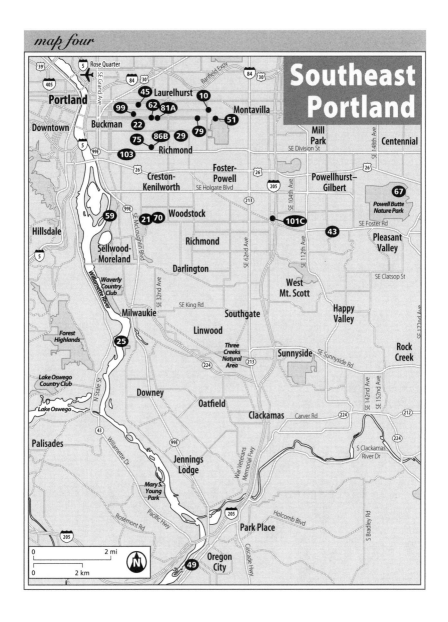

map four

Southeast Portland

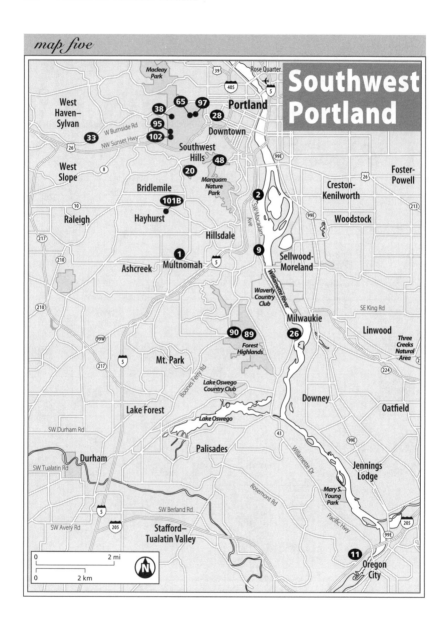

map five

Southwest Portland

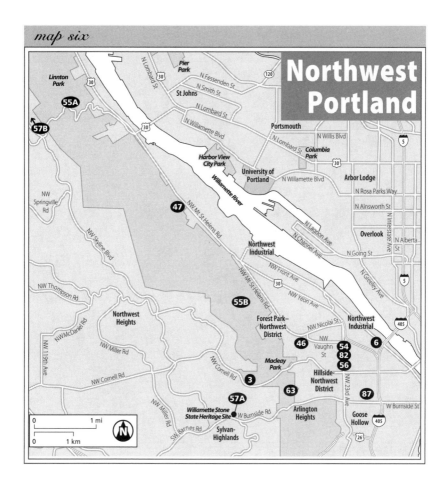

map seven

Outer Northwest

map eight

Aberdeen
101
12 Capitol State Forest
5
Centralia
12
Mt Rainier National Forest

Farther Afield

5

16 Columbia River
Astoria
30
Longview

Gifford Pinchot National Forest

WASHINGTON

Pacific Ocean

74 Clatsop State Forest

St Helens

Carson
17 **12** Hood River
36 84 Columbia River

60

101 Tillamook State Forest **84**

53C
26 47 **30** **Portland** **78** **23**
91 **44** **66** **88**

The Dalles

OREGON 97

Beaverton
92
61 **85** **31** Oregon City
8

26

72

Mt Hood National Forest

26

97

13 Lincoln City

100
Keizer
Dallas **Salem**
76
22

5

Newport
101
Albany
Corvallis Lebanon

5

20 20
126
Redmond Prineville
Willamette National Forest
360

0 20 mi
0 50 km

dedication

May this book help you slow down, go within, seek silence, and know peace.

acknowledgments

*I*t's funny how writing a book about peaceful places became kind of stressful. Of course, the stress was entirely self-created and based in my limitations as a writer: procrastination, lack of organization, and lack of awareness of my surroundings. When I'm writing, I need three things: a place to sit, people to help, and a patient editor. I was blessed with all three throughout this project.

The opportunity came from Molly Merkle and the patience from Susan Haynes, both of Menasha Ridge Press. Susan in particular put up with a lot of the collateral damage from my eternal war with deadlines, and I thank her very much. She also told me about the China Beach Retreat, and there are two of us who appreciate that tip!

Many people came through with great suggestions when I reached out for help. Others just tagged along to keep me company. I *think* I've included them all in this list: Cindy Anderson, Douglas Beers, Patrice Cook, Andy Davis, Food Dude, Jane Garbisch, Maria Garner Jeffrey, Juliet Johnson, Jadene Mayla, Ken McAfee, Steve Moellering, Mich Nelson, Sarah Oliver, Rachel Oliveri, Donovan Pacholl, Donna Ramsey, Maria Liotta-Shindler, Anthony Stevens, Jen Stevenson, Kurt Swensen, Betsy and Mike Tucker, Eric "Vibramhead," and Twitter folk @aurumcat, @oldsweng, and @theknow. (If I forgot anyone, see "lack of organization," above.)

Some photo help came from my lovely assistant, Elisa Pehlke, and also from my very cool "little brother," Roman Dominguez.

And finally, a shout—no, a moment of silence—in gratitude for the Monday Meditators and the rest of my spiritual family. You know who you are, and you are thanked and loved.

introduction

*S*ee if this sounds familiar: One of your first thoughts in the morning is about your schedule and your list of things to do. You get into your routine and start checking things off the list, but then more crop up—meetings to attend, errands to run, people to see. The list is never done. Sometimes it feels as though your schedule and your mind are under attack from outside forces that want to overwhelm both of them, and somebody is working with them to wear you out, and down.

Sadly, I've just described a typical day in my life lately. I like to say yes to projects and social engagements, and I sometimes treat a hole in my schedule the way nature treats a vacuum. As a result, I often look at how I'm spending my time and how I feel, and I think, *Where's the part where I just relax?* Or *Is this what I'm really here for?* And then comes the thought, *You can relax or do what you're here for when you've gotten so-and-so taken care of,* or simply, *I don't have time to relax or pursue my purpose when there's so much to do!*

Turns out I *do* have time. This somebody who is working against me is none other than myself, filling my life with stuff to avoid . . . *something.* It's what the Buddhists call my monkey mind and what Eckhart Tolle calls my egoic mind—ever seeking satisfaction externally, and in some future moment. And while that realization can be frustrating, it's also liberating: I made this mess of busyness, so I can *un*make it.

And so can you. I hope this book helps you along the path of peacefulness. I think it's critical to human health—mental, physical, emotional, and spiritual—that we relax on a regular basis. Slow down. Contemplate. Watch a bird. Our bodies need it, and our minds crave it. I could quote studies on the subject, but instead I'll just say to ask yourself if you could use a little downtime. Trust your answer, and go with it.

At the risk of turning it into just another task, I encourage you, and me, to set aside some time here and there to go for a quiet walk, sit by a stream, get a massage, meet a friend for a quiet drink, stroll through a garden, or get out of the city for a day. Think of it as a useful activity, if you must. But don't turn it into another item on your to-do list. And do leave the phone and laptop at home.

Ironically enough, writing this book got me really stressed-out at times, mainly because I was overcommitted and overwhelmed. My friends always laughed about this in an understanding way. We all knew I had done this to myself, and that it's something we all do, to some extent. At times I wished I had never taken on this assignment, and I was certain I was cobbling together a useless piece of crap.

This morning, with the sun coming through my window and a couple of birds mingling their chirping with the sounds of a bus and streetcar going by, I am looking over the finished product of 103 peaceful places, and I feel quite different. I'm learning to not take on so much, and to commit energy to healing activities such as walking, reading, or just sitting. I am feeling grateful to my guides along the path of writing this book. Now I think the book is quite useful as a guide in itself, showing you some places around town where you might find a little peace, and nudging you in that direction.

Yes, we live in a big city, and yes, we are mighty busy. We're addicted to tasks and technology, and we run ourselves pretty ragged a lot of the time. But peace is all around us, and also within us. Let's take a little time to make that connection again. It's good for us, and therefore good for the world.

Paul Gerald

Portland, September 2012

P.S. This book tells you how to reach destinations by MAX Light Rail, the Portland Streetcar, and TriMet buses. It generally provides information for public transportation that arrives closest to these destinations. If such transport is unavailable or too far away, or where multiple transfers get so complicated that they undermine the tranquil experience, you'll see "n/a" (not applicable).

Crystal Springs Rhododendron Garden (Peaceful Place 21, page 42)

peaceful place 1

ANNIE BLOOM'S BOOKS
Multnomah Village, Southwest Portland (MAP 5)
CATEGORY ↶ reading rooms ⭐ ⭐

*W*alking around Multnomah Village, you may quite easily think that you're in a little town. And it was, in fact, until it was annexed by Portland in 1950. A few buildings go back to 1920 or so, and the neighborhood seems to have everything you'd need in a town, including a little bookstore on the main square.

That would be Annie Bloom's Books, in business since 1978 and specializing in kids' books and others on travel, current events, and cooking—and in customer service: the staff is nice to an almost strange degree. They put a lot of effort into community as well,

Annie Bloom's encourages you to relax and read.

with a newsletter that comes out every couple of months, regular e-mails, and a room upstairs where they host book clubs, or where you can just go chill awhile. The kids' area in the back is extensive as well.

Annie Bloom's has a cat—a "100% real bookstore cat," according to a sign on the feline's bed near the register. Named Molly Bloom, after the wife of Leopold in James Joyce's *Ulysses*, she lives in the store full-time. You will rarely see her on that bed, though; I most often spot her upstairs in the book-group room, lounging in the sun near the window, as a cat should.

You may, of course, buy books in a lot of places in town, and online for that matter, but if you feel like visiting a small town, friendly people, and a mellowed-out kitty, head over to Annie Bloom's.

◡: essentials

⌑ 7834 SW Capitol Highway, Portland, OR 97219

☏ (503) 246-0053

⊕ annieblooms.com

$ Free to browse

☽ Monday–Friday, 9 a.m.–10 p.m.; Saturday–Sunday, 9 a.m.–9 p.m.

🚌 **TriMet Bus:** #44 to SW 36th Avenue and Capitol Highway or #45 to SW 35th Avenue and Troy Street

peaceful place 2

AQUARIVA

Johns Landing, Southwest Portland (MAP 5)

CATEGORY quiet tables ⭐ ⭐

ining at Aquariva feels like eating in somebody's backyard—if that somebody had a gleaming home next to the Willamette River and were a gourmet chef.

It's in kind of a secret neighborhood that looks like a bunch of offices as you whip down Macadam Avenue toward Lake Oswego. But it's in there, next to the fancy Avalon Hotel and Spa. One bonus is that you get to make use of the Avalon's valet-parking service, for no charge. So you feel special on arrival.

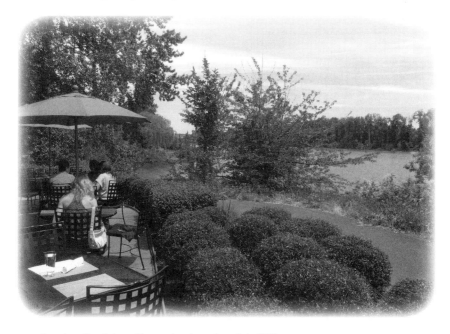

Aquariva offers dining with a nearly private view of the Willamette.

Then you walk through the spacious bar area into the dining room, and if the weather's good—make sure of that before you go—you then pass through another door and out onto a little patio with several tables, surrounded by brush and trees, less than 50 feet from the banks of the river.

Sure, the Willamette Greenway runs between you and the water, so the occasional jogger or bicyclist will whiz by, but hey, that just makes you feel cooler, right? Look at you, on the nice patio, having a pleasant meal!

It's not cheap, but neither is it outrageously expensive for the cuisine and experience. I particularly like the Sunday brunch, with its build-your-own–Bloody Mary–and-mimosa bar, featuring 25 ingredients. It's a fine thing to sit outside, munching on eggs Benedict and omelets, chatting with the charming young servers, gazing out upon the river, and feeling like you're hip to a little secret.

⌣ essentials

Official address: 0470 SW Hamilton Court, Portland, OR 97239
Address for GPS: 4650 SW Macadam Avenue, Portland, OR 97239. Turn east off Macadam onto Hamilton Court and drive to the end, where the valet will take care of your car.

(503) 802-5850

aquarivaportland.com

Entrées: $12–$14 (brunch); $15–$24 (dinner)

Lunch: Monday–Friday, 11 a.m.–2:30 p.m. **Dinner:** Nightly, 5–10:30 p.m.
Brunch: Sunday, 9:30 a.m.–2:30 p.m.

TriMet Bus: #35 to SW Macadam Avenue and Hamilton Court
Portland Streetcar: SW Lowell Street and Bond Avenue (a 0.3-mile walk to the restaurant)

peaceful place 3

AUDUBON SOCIETY OF PORTLAND

West Hills, Northwest Portland (MAP 6)

CATEGORY ↙ outdoor habitats ✪ ✪ ✪

*W*hat a fine word, *sanctuary*. It means, simultaneously, a place where animals can take refuge, a sense of safety, and a sacred or holy place. If you believe there's divinity in nature, then it's all the same thing, isn't it?

That's what you find at the Audubon Society of Portland. Wounded animals are nursed back to health, or perhaps given a life they wouldn't have in the wild. Nestled in the 150 acres are 4 miles of trails winding through the woods and along a creek. And

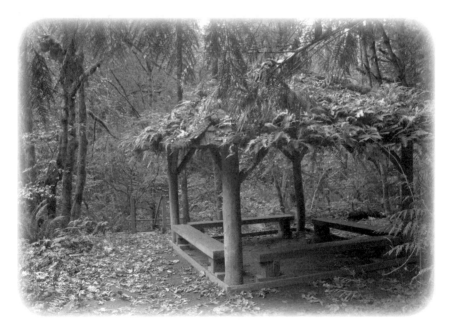

This little gazebo lies just off the main trail.

of course there are plants, birds, and fish. And I happen to think that there's something sacred in all of that.

Start immediately behind the buildings and parking lot, and before you head down the hill, stop in and say hello to the great horned owl, the peregrine falcon, or the red-tailed hawk, or whoever happens to be in the Wildlife Care Center. Then off you go down into the woods, where you can let your intuition lead you onward.

You might find a shelter or a bench or a stand of big old trees. You'll certainly come across the creek, and beyond it the pavilion overlooking a lily pond. Simply wander around, letting it all sink in.

For some real peace and quiet, go across Cornell Road to the other side of the sanctuary, which most people don't even know about. This area has 2 miles of trails, one of which winds along steep hillsides in prime habitat for pileated woodpeckers. If you're lucky enough to see or hear one of these wonderful creatures, you might even think that you're hearing a preacher in a church.

↶ essentials

✉	5151 NW Cornell Road, Portland, OR 97210
✆	(503) 292-6855
🌐	audubonportland.org
$	Free
🕐	Daily, sunrise–sunset
🚍	I normally wouldn't recommend a public-transportation route so far away, but this one gives you a chance to experience two peaceful places at once. **TriMet Bus:** #15 or #77 to NW Thurman Street and 27th Avenue. Walk six blocks to the start of the Macleay Trail (see page 93), and hike through Balch Creek Canyon to the preserve—a trek of about 45 minutes.

peaceful place 4

BONNEVILLE POWER ADMINISTRATION
Lloyd Center District, Northeast Portland (MAP 3)
CATEGORY ✑ museums & galleries ★ ★

*I*f you're younger than, say, 50, you might have a hard time remembering when folks thought the government was pretty cool—or at least that we, through it, accomplished some amazing things. You might also not remember when cutting down trees was considered a heroic effort to tame the wilderness to meet our needs, rather than an environmental disaster. We built dams, we brought electricity, we cleared land, we irrigated fields, we won a war, and we sang songs about it all.

To revisit a slice of these earlier times, head over to the headquarters of the Bonneville Power Administration. In the lobby (which you'll have to pass through a metal detector to enter), a display of old posters and photos from the 1930s onward will capture your attention for some time. They tell a story of a country working together, completing engineering feats, and making lives better for a lot of people.

Eh, maybe I'm merely being sentimental. Maybe I'm waxing Woody Guthrie. The Department of the Interior hired him to write promotional music about the dams being built on the Columbia, and in May 1941 he toured around the area and penned 26 songs about it, including three famous ones: "Roll on Columbia," "Grand Coulee Dam," and "Pastures of Plenty." A library immediately off the lobby features a copy of his *Columbia River Songs* and some other Guthrie mementos. In fact, the circle outside the front door is named for him.

It's nice simply to walk around the lobby, admire the photos and other displays, and at least imagine a time when folks got along a little better.

⌣ essentials

✉ 905 NE 11th Avenue, Portland, OR 97232

☎ (503) 230-3000

🌐 bpa.gov

$ Free (ID required)

🕐 Monday–Friday, 8 a.m.–5 p.m.

🚆 **MAX Light Rail:** Red, Blue, or Green Line to Lloyd Center/NE 11th Avenue

peaceful place 5

BREITENBUSH HOT SPRINGS RETREAT & CONFERENCE CENTER

Detroit, Oregon (MAP 8)

CATEGORY ↵ day trips & overnights ✪ ✪ ✪

onsider what it means to go truly off the grid—no computer, no cell phone, no car. You can achieve all of that at Breitenbush. The retreat also generates its own power from a river that flows from the Mount Jefferson Wilderness, in Oregon's Central Cascades. Geothermal waters heat the rustic cabins, and solar power turns organic matter into compost. The food? It's all organic and vegetarian.

But this site is off the grid in deeper, more meaningful ways. Here you'll find a self-governing community, set in an ancient forest, offering you a chance to leave your busy

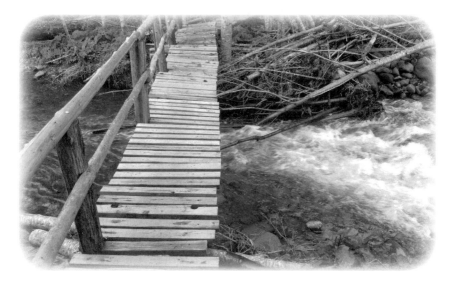

Footbridge over Devils Creek near Breitenbush Hot Springs

world for a while. Come here to soak in warm waters, walk in the woods, get a massage, read, listen to music, attend a spiritual workshop, or simply sit quietly. Outside the meditation hall, you'll see both a Buddha and a Virgin Mary.

Breitenbush welcomes many types of people. At first glance you may think *hippie*, and you may be put off by nudity. But the nakedness is optional and for the pools only.

Go to Breitenbush. Spend the day, spend a night, spend a week, or even camp in the summer (your tent or theirs). Look for your own peace and your own version of spirituality. Go off grid awhile. And try going during the week in spring or fall to encounter fewer fellow retreaters.

↩ essentials

☰ Breitenbush Hot Springs, Detroit, OR 97342
From I-5 at Salem, take Exit 253 and head east on OR 22 toward Stayton/Detroit for approximately 49 miles to Detroit, Oregon. After crossing the Detroit bridge, turn left onto National Forest Road 46. Drive 9.1 miles, and then just past Cleator Bend Campground, take a right onto a bridge over the Breitenbush River. After the bridge, the road is gravel. Take a left at the next three forks and arrive at your destination. An alternate route, OR 224, is open only during summer.

✆ (503) 854-3320

🌐 breitenbush.com

$ Reservations required for all visits. Day use is sliding scale: $14–$26 for adults, $7–$13 for children ages 5–12 (children under age 5 free). Overnight lodging rates depend on season, day of week, and your privacy preferences; range is $55–$117, all meals included.

🕐 **Day use:** Daily, 9 a.m.–6 p.m. **Lodging:** 24/7. Occasional closures of up to a week. Check website for details.

🚍 A ride-share program is available to registered guests.

peaceful place 6

BREKEN KITCHEN

Outer Pearl District, Northwest Portland (MAP 6)

CATEGORY ↝ quiet tables ★

he first time a friend suggested Breken Kitchen to me, I couldn't even find it. First, I thought, *There's nothing past the Fremont Bridge but some warehouses and rail yards.* Then I tried to drive to the address and messed that up. Even TriMet gets no closer than about 0.5 mile. When I finally tracked the restaurant down, it introduced me to a nearly secret little neighborhood, with a school, restaurant, tea merchant, and meat shop. Who knew?

Breken Kitchen's vintage feel and historic surroundings make it a real find.

On walking in, I found a large, clean, well-lit place that, after I looked for a bit, I found oddly shaped. One end of the building is decidedly narrower than the other, and I later found out that this so-called Triangle Building dates to 1900 and was originally used to store wire products. So Breken Kitchen is at the narrow end of a building in a neighborhood where culture sticks out toward the Willamette River, under a bridge, by the trains.

But it's far from dive-y. It has the usual full range of coffees and teas,

plus wine and beer, and it features delicious pastries baked on-site. The food is pretty serious, too: last I checked, the lunch special was a panini with pepper bacon, roasted shiitakes, Brie, and roasted onions. Definitely serious.

But the main draw of the place is its vibe. It really does feel like a little outpost of Pearl District café culture, where you can chill with a laptop or conduct a casual business meeting. It's particularly nice in summer, when the windows are open and the river air breezes through. (If you're seeking complete solitude, though, time your visit to avoid when the Montessori School across the street lets out.)

So see if you can find it—if you can, you'll find it a lovely place to hang out.

↙ essentials

▱	1800 NW 16th Avenue, Portland, OR 97209
☎	(503) 841-6359
⊕	brekenkitchen.com
$	$2–$9
⊙	Monday–Friday, 7 a.m.–5 p.m.
⛉	**TriMet Bus:** #77 to NW Northrup Street and 18th Avenue **Portland Streetcar:** to NW Northrup Street and 18th Avenue

peaceful place 7

BROADWAY BOOKS

Irvington, Northeast Portland (MAP 3)

CATEGORY ⌣ shops & services ✪ ✪ ✪

*G*od bless the independent bookstore. I say that, of course, as a writer and a publisher—in other words, somebody interested in selling books. But really, I say that as a citizen.

We all know the wonders of Amazon and e-books and iPads, and they're all just fine. But if the bookstore goes away, think of what will be lost. Or think of it this way: if you

Who said the brick-and-mortar bookstore was dead?

had a machine at home that could spit out whatever meal you wanted, that would be cool, but you'd miss restaurants, wouldn't you?

You'd miss bookstores, too. You'd miss holding books in your hand, reading a few pages to get a taste, and wandering the aisles to marvel at the myriad subjects: spirituality, action and adventure, romance, science fiction, fantasy, and all the others.

And you'd miss standing near someone who sees what you're holding and says, "Oh, I liked that one," leading to a conversation. I have a good friend who met his wife in the aisles of an indie bookstore:

she was in the poetry section and he thought she was cute, so he grabbed his favorite Shel Silverstein, walked over, and read her a couple of things. They have three kids now.

That wouldn't happen on Amazon, would it? Portland is blessed with a few good bookstores, and Broadway happens to be my favorite. The next time you're curious about a book, go to a store instead of a website. You'll be among friends, and you never know what might happen.

↻ essentials

| ✉ | 1714 NE Broadway, Portland, OR 97232 |

| ☏ | (503) 284-1726 |

| 🌐 | broadwaybooks.net |

| $ | Free to browse |

| 🕐 | Monday–Saturday, 10 a.m.–7 p.m.; Sunday, 10 a.m.–5 p.m. |

| 🚌 | **TriMet Bus:** #77 to NE 17th Avenue and Weidler Street or #9 to NE 17th Avenue and Broadway |

peaceful place 8

BROOKSIDE INN ON ABBEY ROAD
Carlton, Oregon (MAP 8)
CATEGORY ↵ day trips & overnights ✪ ✪ ✪

*O*n a drive through the famed Willamette Valley wine country, you could pass right by the Brookside Inn, and if you even noticed it, you might think, *Oh, a place with a pond.* And it is that. It is also, I was told by a friend who guides groups around the wine country, "super-duper chill." That was enough to get me there.

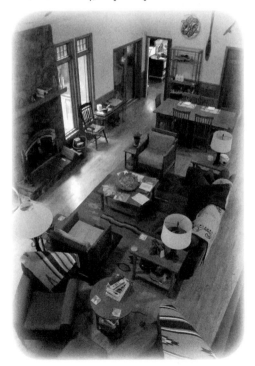

The living room and big fireplace at the Brookside Inn

From there, it was one wonderful realization after another. It's a luxury country inn with nine guest suites on 22 acres with gardens and fruit trees. Oh yes—and a 5-acre pond.

But this is no ordinary pond. The inn's owners, who have exclusive rights to dam Millican Creek, struck a deal with the Oregon Fishing Club, which is restoring the water quality and shore. The club also stocked it with rainbow trout, which share the pond with an aggressive population of resident bass.

So what does this have to do with Brookside guests? The terms of the deal say that club members

can fish anytime they want, but they can't cross the bridge to the inn; meanwhile, guests at the inn can fish whenever they want, even without a license. That's right—the front lawn of your luxurious country inn has a private pond stocked with two of the hardest-fighting species known, and the fish are maintained for their health and prosperity. Plus, it's all catch and release with flies only, so all those fish are getting bigger and bigger.

If you don't fish, you'll love hanging out by the water under a shade tree or sitting on the deck looking at the garden and trees, getting to know Susan the owner and Maxine the cat. Both are delightful. You can borrow a couple of bikes and cruise the back roads, drive to a bushel of wineries in the area, go two minutes down the road to the Trappist Abbey (see page 123), or follow Susan's advice for some amazing restaurants in the area. Or simply sit by the fireplace in the spacious living room, reading a book and enjoying some local wine.

When we left in the morning, a final surprise awaited us. We knew Brookside was a bed-and-breakfast, but we didn't know that we'd start with fresh-roasted coffee made in a French press, plus homemade granola and fluffy Greek yogurt. When Susan asked if we wanted pancakes, we didn't realize that they were made with blueberries and hazelnuts, both bought from local farms. The eggs are local as well. And it was all delicious.

We had no idea what was going on behind that little pond by the road—but we do now. And we can't wait to get back.

⌣ essentials

▣	8243 NE Abbey Road, Carlton, OR 97111
ℭ	(503) 852-4433
⏣	brooksideinn-oregon.com
$	$185–$300 per night
☽	24/7
⛟	n/a

peaceful place 9

BUTTERFLY PARK NATURESCAPE
Corbett–Lair Hill, Southwest Portland (MAP 5)
CATEGORY ↲ parks & gardens ✪ ✪ ✪

I have yet to meet one person who knew that Portland had a butterfly park. And even if you knew where it was and you went there, you might reasonably ask two questions: Is this the whole park, and where are the butterflies?

Well, yes, this 1.09 acres is the whole park. But for perspective, here's a little history. This was a gravel parking lot and dump for the Macadam Bay Club—in other words, another forgotten patch of Willamette riverbank, presumed to be creepy if not

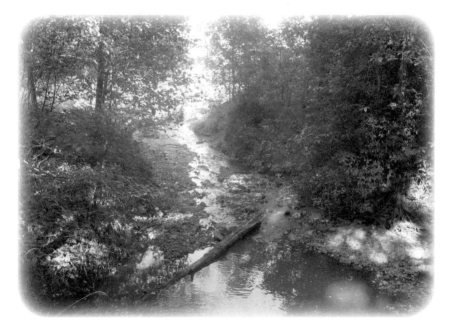

A tiny creek flows through equally tiny Butterfly Park.

dangerous. But the city bought it 1984, and starting in 1991 volunteers planted it with wildflower seeds from the Columbia River Gorge. Now those flora grow among native grasses under dogwoods, oaks, and cottonwoods—just as on a natural riverbank. The area is part of the South Portland Riverbanks Project, which is restoring 35 acres of wooded riverbank to fish-friendly environs.

And yes, this little patch of nature was planted with butterflies in mind; in fact, the city says that it's visited by morning cloaks and orange sulfurs, among others, as well as birds such as cedar waxwings, killdeers, orioles, and chickadees.

To find the naturescape, park just off Macadam Avenue at the entrance to Macadam Bay or walk south a few minutes on the paved Willamette Greenway Trail from Willamette Park. You'll see an interpretive sign and an unpaved path heading through some brush toward the river—and yes, that's the whole park.

But it's a nice little park, and as close to a secret as a city park can be. You'll probably have it to yourself to enjoy the views of the river, of the Sellwood neighborhood across the way, and—who knows?—maybe even a butterfly or two.

⌣ essentials

📧	7720 SW Macadam Avenue, Portland, OR 97219
📞	(503) 823-7529
🌐	tinyurl.com/butterflypark
$	Free
🕐	Daily, 5 a.m.–midnight
🚌	**TriMet Bus:** #35 or #36 to SW Macadam Avenue and Taylors Ferry Road

peaceful place 10

CALDERA PUBLIC HOUSE
Mount Tabor, Southeast Portland (MAP 4)
CATEGORY ↙ quiet tables ⭐ ⭐

*C*aldera, named for the extinct volcano on whose shoulders it rests, harks back to the days of yore.

It's a restaurant, sure, and a bar. But it's also a public house, and its setting in an almost entirely residential area accentuates that aspect. Southeast Stark Street makes a long, slow descent from the heights of Mount Tabor into southeast Portland. Up toward the top of Stark, around SE 60th Avenue, sit a church, a coffee shop, a photo studio, and Caldera—a quiet little neighborhood.

Caldera Public House's lovely backyard

Caldera serves this community with unpretentious food, some beers and wines, and a warm, cozy setting in a building that dates back some 100 years.

Walk across the creaky wood floors to find a high-backed booth, settle at the big wooden bar, or grab a little couch or table for two in the back room. Or, best of all, if it's summer, go out back.

There you'll find a tiny fenced-in yard, overhung by trees, adorned with lights, and hosting picnic tables—each with a candle. The crowd, even when the yard is full, isn't rowdy or loud. I often visit on Sunday evenings, and it might be tough to get a table when the weather's nice, but I don't know of many places in town that can match the overall comfort of the place, from the menu to the yard.

Simply a quiet little public house up the hill a ways, on a quiet street. Just what a neighborhood needs.

✌ essentials

📧 6031 SE Stark Street, Portland, OR 97215

📞 (503) 233-8242

🌐 calderapublichouse.com

$ **Entrées:** $8–$14

🕐 Monday–Thursday, 5–11 p.m.; Friday, 4 p.m.–midnight; Saturday, 5 p.m.–midnight; Sunday, 5–10 p.m.

🚌 **TriMet Bus:** #71 to SE 60th Avenue and Stark Street

peaceful place 11

CAMASSIA NATURAL AREA

West Linn, Oregon (MAP 5)

CATEGORY ↙ outdoor habitats ✪ ✪ ✪

*I*t feels as though there's a wall built around Camassia Natural Area. Two of them, actually.

One is a wall of silence, although nobody goes out of their way to keep the place's existence secret. The Nature Conservancy, which owns it, has a page about it on its website. Newspaper articles have appeared here and there. But ask somebody about it and they'll either look at you blankly or say something like, "I've been meaning to check that place out."

A pastoral scene in a suburban setting

If you do check it out, you'll feel the presence of that second wall—of vegetation trying to keep everyone out. Of course, that enclosing forest is part of the appeal, but the real attractions of the place are surrounded by that forest: a series of meadows that in early spring comes alive with rare wildflowers.

There are forest flowers, as well, and the experience of visiting Camassia at peak bloom (usually mid-April–early June) is like finding a fairy-tale land behind your own house—or a subdivision full of houses, in this case, along with West Linn High School. The preserve represents the last 26-acre fragment of what used to spread over all these parts: white-oak and madrone forest scattered with rocky meadows, all of it filled with springtime flowers.

In a typical year, the best time to visit is April and early May. That's when you'll see the type of camas that gave the place its name. You'll also be in the company of wild roses, fawn lilies, and some 300 other species.

To walk the loop trail (less than a mile long) is to hear birds, smell flowers, wade through waist-high grass, admire a small pond, and take in nature's peace—all within earshot of I-205. And, of course, to be grateful for the protection of those "walls."

⌣ essentials

▤	5000 Walnut Street, West Linn, OR 97068; see websites below for driving directions.
✆	**The Nature Conservancy in Oregon:** (503) 802-8100
⊕	tinyurl.com/camassia or oregonwildflowers.org/viewlocation.php?ID=39
$	Free
☽	Daily, sunrise–sunset
🚌	n/a

peaceful place 12

CARSON HOT SPRINGS SPA & GOLF RESORT
Carson, Washington (MAP 8)
CATEGORY ↙ historic sites ★ ★

*I*t's really kind of magical if you think about it: soothing hot water filled with minerals, bubbling up from the ground. Entire industries have grown up around it, of course, some of them quite fancy.

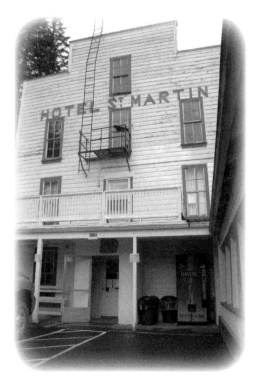

The 101-year-old hotel at Carson Hot Springs

Not so at Carson Hot Springs. In 1876 a hunter noticed steam beside a creek and marked the spot. By 1901 he had built a hotel, which still stands. Bathhouses, also still in use, were added in 1923. All because of the water.

Carson has fancied up a *little*, with a new hotel and some remodels, and in 2012 it added a golf course and a restaurant, the Elk Ridge Grill.

But the essence remains the same: a quiet little corner of woods near a stream, with a trail heading into the forest, and a rustic scene where you first soak in a claw-foot tub (with or without swimsuit—up to you), the warm water pumped straight in from the riverbank.

Next they wrap you in warm, wet towels. Then you can get a massage. *Ahhh.*

It's not hippie-fied like Breitenbush or glamorous like Bonneville Hot Springs—but I think that's the point. You simply take the hot water from the spring, put it in a tub, soak in it, and then get pampered a bit. It's so nice, in an old-fashioned way. In fact, as I said, it's kind of magical.

⌣ essentials

📧	372 St. Martin's Springs Road, Carson, WA 98610
📞	(509) 427-8296
🌐	carsonhotspringresort.com
$	$70 for a one-hour massage (with reservation); $20 for a soak and a wrap (first come, first serve)
🕐	Daily, 9 a.m.–7 p.m.
🚌	n/a

peaceful place 13

CASCADE HEAD

North of Lincoln City, Oregon (MAP 8)

CATEGORY ↙ day trips & overnights ✪ ✪

I see the whole point of conservation as telling the capitalist world of development, "Stop." Or at least, "Not here." We make little stands against the machine that would turn everything into homes and malls, and then we keep fighting to protect those areas.

A line was drawn at Cascade Head in the early 1960s. Somebody was going to turn one of the last coastal headland meadows into a housing development, so locals gath-

A waterfall tumbles onto the beach at Harts Cove.

ered money, bought it, and handed it over to The Nature Conservancy. Thank goodness.

You'll feel that gratitude when you pop out of the woods more than 1,200 feet above the ocean and you're looking at a meadow filled with flowers, seemingly roll-ing down to the sea. Or when you park by the mouth of the Salmon River and wander up through the woods and over creeks, and you probably catch sight of some elk when you hit the lower meadows. Or when you hike among the ancient Sitka spruces to another

meadow at Harts Cove, where a waterfall plunges onto a remote beach and sea lions bark across the way.

The rock-star animal species, as it were, is the Oregon silverspot butterfly, which is known to exist in only five places in the world. But I've seen elk on every visit, and there are reports of bald eagles, coyotes, and all sorts of other birds and rare plants.

But the real magic of Cascade Head is just being here, sitting in the grass, looking out over the ocean, and feeling grateful that such places are still with us.

⌣ essentials

≡ **Lower trailhead GPS coordinates:** N45° 2.535' W123° 59.512'
Upper trailhead GPS coordinates: N45° 3.641' W123° 59.305'
Visit the websites below for driving directions.

☎ n/a

🌐 portlandhikersfieldguide.org/wiki/cascade_head_hike or tinyurl.com/cascadehead

$ Free

🕐 24/7. The lower trailhead is open year-round; the road to the upper trailhead is gated January 1–July 15.

🚌 n/a

The Salmon River and the sea beyond from the top of Cascade Head

peaceful place 14

CATHEDRAL PARK

St. Johns, North Portland (MAP 2)

CATEGORY ⌖ parks & gardens ✪ ✪

*A*s easy as it is to forget nature when in the city, we can also slip into thinking of Portland as small and quaint, forgetting that sometimes it serves up *monumental* as well.

Both the need for nature and any undermining of Portland are cured by a visit to Cathedral Park, which seems unknown to most Portlanders even though they drive right over it all the time.

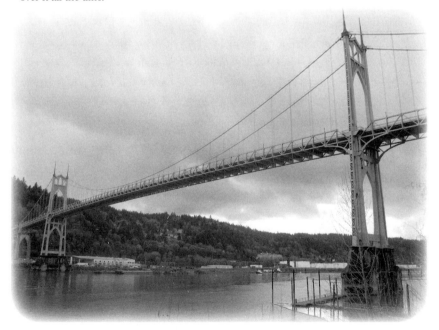

Cathedral Park gets its name from the churchly design of the St. Johns Bridge supports.

The park lies under the St. Johns Bridge, which is about as large-scale and classy as Portland can get. Did you know that when the bridge opened in 1931, it had the highest clearance in the nation? That it was the longest suspension bridge west of Detroit? Today it sees more than 20,000 cars daily, but nowhere near that many ever visit the spacious, quiet park below.

To go down there is to truly appreciate the grandeur of the bridge, whose 400-foot Gothic towers and cathedral-like arches gave the park its name. Visiting here will also reinforce a fact about Portland that's sometimes lost: this city is a river town. There's a boat ramp here, as well as ducks and geese and picnickers, and the occasional seagoing vessel cruises by.

Meriwether Lewis and William Clark are believed to have camped here, and we know that the founder of the adjacent St. Johns neighborhood homesteaded here in 1847. In the 1970s, the area was an informal junkyard, so neighborhood activist Howard Galbraith, dubbed the Mayor of St. Johns, led a drive to make it a park.

Down at the park, the bridge's US 30 traffic is far enough overhead that the sounds won't disturb you. Downtown is far enough downstream that you'll feel as if you're out in the country. And the bridge is big and beautiful enough that you'll remember that sometimes Portlanders do things on a mighty impressive scale.

⌣ essentials

📧	North Edison Street and Pittsburg Avenue, Portland, OR 97203; **GPS coordinates:** N45° 35.245' W122° 45.680'
☏	(503) 823-7529
🌐	tinyurl.com/cathedralpark
$	Free
🕐	Daily, 5 a.m.–midnight
🚌	**TriMet Bus:** #17 to North Syracuse Street and Philadelphia Avenue or #4 or #75 to North Lombard Street and Baltimore Avenue

peaceful place 15

CENTRAL

Old Town, Central Portland (MAP 1)

CATEGORY ✌ urban surprises ✪ ✪

*I*t occupies one of the oldest buildings in this part of Portland. It's down an alley that by day is choked with tourists eating Voodoo Doughnuts. And it's tucked behind what looks like a restaurant's workshop. There's no sign.

If you know about it—and now you do—you can visit Central and feel a bit more in the know for showing up. (No need to thank me.) The owner told *The Oregonian* that he does no advertising or marketing, and in fact he used to run an innocent-looking *crêperie* out front.

It has since expanded its food menu, and in summer it spreads tables out into the pedestrian-only alleyway. But the coolness of this place definitely lies in the late-night scene inside, where a fan slowly spins overhead, antique table lamps light the room, and an amazing flow of hip, creative cocktails pours out of the bar. One, called Top 5 Desert Island, consists of Martin Miller's Westbourne Strength Gin, Perrier Pamplemousse Rose (grapefruit-flavored mineral water), Liquore Galliano, lemon, honey,

Central is a little vintage, a little funky, and very private.

cinnamon, and Peychaud's Bitters. I am barely cool enough to know about Central, and nowhere near cool enough to know what most of those ingredients are.

But I love Central because hanging out there makes me feel like an adult who can dress up and have a quiet drink downtown. Being here also takes me away from myself a little. It's a secret bar, hidden down an alley. I'll meet you in the back and we'll get a drink. There's even a happy hour at 11 p.m.—who knows what will happen?

⌣ essentials

☰ 220 SW Ankeny Street, Portland, OR 97209

✆ (503) 719-7918

🌐 centralpdx.com

$ **Entrées:** $10–$20; **cocktails:** $8–$13

🕑 **May–October:** Tuesday–Friday, 4 p.m.–2 a.m.; Saturday, noon–2 a.m.; Sunday, noon–midnight. **November–April:** Times change seasonally.

🚃 **MAX Light Rail:** Red or Blue Line to Skidmore Fountain

peaceful place 16

CHINA BEACH RETREAT
Ilwaco, Washington (MAP 8)
CATEGORY ⌇ day trips & overnights ✪ ✪ ✪

*W*e soaked in the hot tub and watched the moonlight on the ocean. We listened to seabirds singing. We watched fishing boats come and go. We ate dinner on a private porch at sunset. We watched a heron wait for its meal. We roamed a recreational paradise. This was our weekend at the China Beach Retreat, a secluded little piece of coastline on the Long Beach Peninsula in Washington's far southwest corner, less than a three-hour drive from Portland.

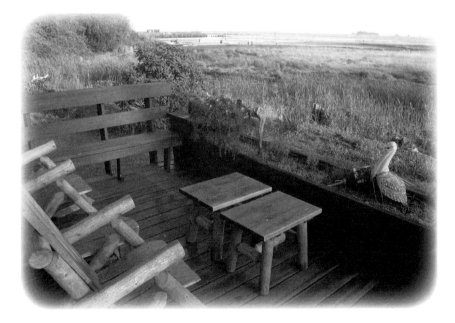

Rocking chairs line the porch of the Main House at China Beach.

The retreat overlooks Baker's Bay, on the north side of the Columbia River's mouth, at the intersection of rustic charm, gritty seafaring work, and natural splendor.

The owners, David Campiche and Laurie Anderson, also own the historic Shelburne Inn, 5 miles north in Seaview, Washington. When you stay at China Beach, you typically eat breakfast at the Shelburne.

While the Shelburne is a rambling country-style inn with a gourmet restaurant, antique-filled rooms, and a history that goes back to 1896, it still sits on the Long Beach Peninsula's main (though narrow) two-lane road. China Beach, however, lies down a tiny road with a locked gate in a hidden cove. There's a big house with three bedrooms and a living room with floor-to-ceiling plate glass windows looking out at the bay; a mounted telescope helps keep an eye on the birdlife. You can get one of the rooms B&B-style, with morning meals at the Shelburne, or you can rent the whole place.

The real treasure here, though, may be the other building, the one-bedroom Audubon Cottage. That's where we stayed, and it's a masterwork of wood, tile, glass, and privacy. When you're not stretched out on the king-size bed or laid out in a chair on the deck, you can get lost in the rich details of the craft. A sign explains that 7 "general use" woods were used in the construction of the place and that 18 different types were used in the trim. These include such exotics as Brazilian rosewood, Carpathian elm burl, 162-year-old red cedar that washed up on the shore, thousand-year-old coast redwood, and Alaska yellow cedar with 65 rings per inch.

The overall effect is one of soothing luxury combined with rustic simplicity. We can't be the only couple who still purr at the memory of that front-porch, two-person hot tub.

All around you are the recreational pleasures of the Long Beach Peninsula: Cape Disappointment State Park is known for hiking and wildflowers. Two lighthouses guard the surrounding Pacific waters, known as the Graveyard of the Pacific. A dozen sites within Lewis and Clark National Park provide history. Fresh fish abounds on the docks and in the nearby restaurants in the quaint villages strung along the narrow 28-mile-long peninsula. Beaches with solitude and pounding surf are never far away on this stretch of land.

And all of that is wonderful, to be sure. But if you go to China Beach, you're more likely to come away thinking about the peace of Baker's Bay, the call of the birds, and the moonlight soaking.

✌ essentials

📧 **China Beach guest quarters:** 222 Robert Gray Drive, Ilwaco, WA 98624

📞 (360) 642-6442

🌐 chinabeachretreat.com or theshelburneinn.com

$ **Main House:** $199–$229 per night. **Audubon Cottage:** $289 per night. Discounts October–June and for renting multiple rooms.

🕐 24/7

🚐 n/a

China Beach's charming Audubon Cottage

peaceful place 17

COLUMBIA GORGE INTERPRETIVE CENTER MUSEUM
Stevenson, Washington (MAP 8)
CATEGORY ⌣ museums & galleries ✪ ✪

*T*hese days, we tend to think of the Columbia River Gorge as a scenic
and recreational corridor.

We forget sometimes that for thousands of years, it was simply a place to live, inhab-
ited by a thriving, multilingual human culture based on fishing, hunting, and com-
merce. Then came a whole new wave of people who saw the gorge as a wilderness to
be conquered: cut the trees, catch the fish, build farms and towns, construct roads and

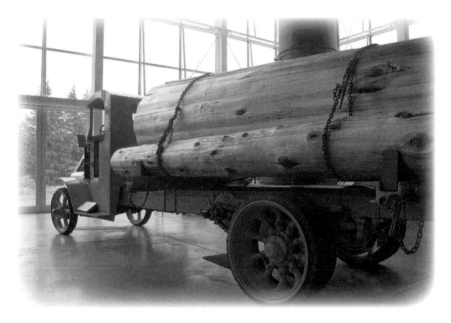

Old logging equipment brings history alive at the Columbia Gorge Interpretive Center.

railways. The pendulum has swung, so now it's all about recreation, preservation, and striking the right balance.

Throughout it's a human saga, and it's what you find at the Columbia Gorge Interpretive Center, a quiet, nearly overlooked little museum on the grounds of Skamania Lodge. The First Peoples story is told with artifacts and an impressive library of books on the subject. The experiences of the Europeans are related through the journals of Meriwether Lewis and William Clark, along with archeological records. The story of commercial fishing is represented by a full-scale fishing weir in a large hall that also houses an airplane. A massive steam engine and a 1921 Mack truck signify the logging industry. There's even a locomotive you can check out. And in a contemplative vein, a spiritual gallery features the world's largest collection of rosaries.

Surprising, huh? So is this museum. And so is the whole ongoing story of the gorge.

essentials

990 SW Rock Creek Drive, Stevenson, WA 98648

(800) 991-2338 or (509) 427-8211

columbiagorge.org

Adults, $10; children ages 6–12 and seniors age 60 and older, $6; students, $8; family rate, $30

Daily, 10 a.m.–5 p.m.; closed January 1, Thanksgiving, and December 25

n/a

peaceful place 18

COLUMBIA POINT WALKWAY
Hayden Island, North Portland (MAP 2)
CATEGORY ↝ enchanting walks ✪ ✪ ✪

*M*y first recollection of Columbia Point was somebody telling me about a walkway behind some condos on Hayden Island. That didn't sound appealing, helpful, or legal. But I winged it and found a little strip of parking between the Red Lion Hotel and, well, some condos. It's right where a fire lane cuts off to the left, behind the hotel.

And by golly, there *was* a walkway, winding along the river, with a sign saying (more or less) BE NICE OR WE WON'T LET YOU WALK HERE ANYMORE. The first stretch was along the riverfront, with airplanes flying low on approach to PDX

The Columbia Point Walkway passes a boat basin—mind your p's and q's.

(Portland International Airport), boats and barges going by, and the I-5 bridge humming with traffic.

After a bit of this, the path, which is paved and lit and dotted with benches, turned a corner into a boat basin filled with yachts and sailboats. Now I really felt as if I was intruding someplace, but the occasional BE NICE OR ELSE sign was actually comforting by now.

The path wraps around the boat basin, offering views of water and sky and the way you would live if you had lots of money. You'd have your condo here, and your boat down there, and you'd go on evening cruises, or maybe a big adventure to Seattle or up the gorge, and you'd go for morning jogs or after-dinner strolls along the river, to look for fish and birds and think about how lucky you are.

The good news is that you can do those last parts anyway . . . as long as you do them *nicely.*

⌣ essentials

▣	909 North Hayden Island Drive, Portland, OR 97217 (*Note:* Take care not to confuse this street with North Hayden Island *Bay* Drive, which is in the same area.)
ℂ	n/a
⊕	n/a
$	Free
⊙	24/7
⊟	n/a

peaceful place 19

COMMON GROUND WELLNESS CENTER

Concordia, Northeast Portland (MAP 3)

CATEGORY ⌣: shops & services ✪ ✪

*I*t's an ancient thing, humans and hot water. As long as we've walked upright, and maybe before that, we have wanted to lower ourselves into pools of soothing goodness, to relax and restore ourselves, to float around in tranquility.

Come on in—the water's fine at Common Ground's outdoor soaking pool.

Somewhere along the way, we lost our balance. Maybe it was capitalism, but we sure started working a lot, stressing out over material items, forgetting the basics of self-care and wellness. Happily, now it feels as though maybe we're getting that groove back, rediscovering the benefits of soaking, massage, acupuncture, and naturopathic medicine.

It certainly feels that way at Common Ground, starting with the moment you walk in the door. The vibe there bespeaks peace and welcome and quiet. In fact, there's even a quiet hour every night at 10 p.m. There's an outdoor soaking pool with a

little rain cover on the side, along with a cedar sauna. And yes, virtually everybody is naked; there are gender-specific times if you prefer that.

The basic deal is that you make a reservation and pay $14 for an hour (other prices available) for soaking and sauna, and you can make appointments for massage and the other services. My favorite is the Massage Sandwich: 90 minutes in the bathhouse with a one-hour massage in the middle. *Mmmm.*

A warning, though: After you treat yourself to such a thing, modern life might seem hectic and stressful for a while.

⌣ essentials

▣ 5010 NE 33rd Avenue, Portland, OR 97211

ℭ **Reservations:** (503) 238-1065

⊕ cgwc.org

$ **Massage:** 30 minutes, $40; 1 hour, $70; 90 minutes, $100; 2 hours, $130. **Soak and Sauna:** (members receive $3 discount) 30 minutes, $10; 1 hour, $14; 90 minutes, $18; 2 hours, $22; children ages 6–12, $3 per hour (children welcome before 8 p.m.). Monday–Friday, 10 a.m.–1 p.m., community members receive 1 hour Soak and Sauna for $10. **Massage Sandwich:** nonmembers, $82; members, $79.

🕤 Daily, 10 a.m.–11 p.m. Open at 11 a.m. the second Wednesday of every month. **Men-only hours:** Monday, 7–11 p.m.; **women-only hours:** Tuesday, 7–11 p.m. and Saturday, 10 a.m.–noon. Check website for additional group time slots.

🚌 **TriMet Bus:** #73 to NE 33rd Avenue and Webster Street or #72 to NE 30th Avenue and Alberta Street

peaceful place 20

COUNCIL CREST PARK

West Hills, Southwest Portland (MAP 5)

CATEGORY ⌣ scenic vistas ⭐ ⭐

*T*here's something appealing about attaining the local high spot.

Maybe it's our urge to conquer or seek perspective, but in the case of Council Crest, the good news is that you don't have to conquer it at all. You can hike it, sure, but you can also drive or take the bus. And being at the highest point in all of Portland always gives you a nice perspective—and at least two nice views.

Once you're up there, go to the stone circle at the top of the park. Within this enclosure, surrounded by a low-slung stone wall, plaques point out four visible volcanoes and display a native name for each. The vista frames Mount Hood in a particularly pleasant way, with a grassy slope in the foreground. To the east you can see into the Columbia

Not just for humans: Sunset views and open spaces make Council Crest Park a nice place to wind down the day.

River Gorge. The view to the west goes out to Beaverton and, on a clear day, to the Coast Range. Needless to say, this is a high-priority sunset spot.

For an odd, secret treat, stand on the small metal disc in the middle of the circle, face the city, and say something like, "Portland rocks!"

My favorite sweet spot is a pair of benches facing Mount Hood. But take a moment from enjoying the view to note the birth and death dates of the couple to whom the benches are dedicated: Frank and Nadia Munk both lived nearly 100 years and died within a year of each other. After they fled Nazi-occupied Czechoslovakia in 1939, Frank (a political activist back home) taught economics and political science at Reed College (see page 141), UC Berkeley, and Portland State University. Nadia helped establish the park you're sitting in—which in its former incarnation was an amusement park 1907–1929—and 44 years ago she convened meetings in her home to save Marquam Gulch, through which you hike to reach Council Crest. That group, which became Friends of Marquam Nature Park (see page 97), stopped plans for apartments in the ravine below you and lobbied for multiple trailheads to make the area accessible as a retreat from the urban world.

We can thank them for the trails, and Portland for the view and the perspective.

∿ essentials

🖥	SW Council Crest Drive at Fairmount Boulevard, Portland, OR 97255 **GPS coordinates:** N45° 29.932' W122° 42.476'
☎	(503) 823-7529
🌐	tinyurl.com/councilcrest
$	Free
🕐	Daily, 5 a.m.–midnight; closed to cars at 9 p.m.
🚌	**TriMet Bus:** #51 to Council Crest Park

peaceful place 21

CRYSTAL SPRINGS RHODODENDRON GARDEN
Eastmoreland, Southeast Portland (MAP 4)
CATEGORY ↙ parks & gardens ✪ ✪

*E*very year, something like an explosion occurs at Crystal Springs. It happens right around Mother's Day, when hundreds of rhododendrons and azaleas burst into bloom—and waves of humanity descend upon the place to admire them. It's an astonishing display all around. The blooms, and most of the crowds, linger well into June.

Well, not many folks think about this fact, but this 60-year-old treasure of a garden is open year-round. In fact, one could argue that it's as much about water and birds and blooming shrubs, and along those lines, winter might be the best time to go. There are

It's all about water and blooms at Crystal Springs.

94 species of birds that at least stop by, many of which hang around the spring-fed lake that almost surrounds this 7-acre park.

You can hang around one of three waterfalls, stroll over a couple of scenic bridges, or find a quiet spot along the lakeshore. The ducks, geese, and even herons are accustomed enough to seeing people that you won't scare them off, and some of the geese might even follow you around, begging to be fed. Kids in particular will find this thrilling, of course.

The May–June bloom is spectacular too, of course; see if you can sneak off during the week to see it. More than 2,000 rhodies, azaleas, and other plants grow in the garden, including many rare and hybrid species. The oldest rhododendron in the garden dates from before 1917, and the chances are excellent that you'll see the biggest rhodies of your life here.

✥ essentials

⌑ 6015 SE 28th Avenue (one block north of Woodstock Boulevard), Portland, OR 97202

🄲 (503) 823-7529

🌐 tinyurl.com/crystalspringsgarden

$ Day after Labor Day–February 28 or 29, free; March 1–Labor Day, $3

🕒 **April 1–September 30:** Daily, 6 a.m.–10 p.m.
October 1–March 31: Daily, 6 a.m.–6 p.m.

🚌 **TriMet Bus:** #19 to SE 32nd Avenue and Woodstock Boulevard, 0.2 mile away

peaceful place 22

DHARMA RAIN ZEN CENTER
Hawthorne, Southeast Portland (MAP 4)
CATEGORY ↙ spiritual enclaves ✪ ✪ ✪

here's always a bit of mystery about Buddhism, Zen Buddhism in particular. The core practice in this school is sitting meditation, and it is quite often done while facing a wall. Wandering in off the street, one might wonder, "What are these people doing, staring at the wall, and how is that supposed to help?"

As for what they're doing and how it helps, well, for centuries there have been volumes written and talks given on that subject. All I can add is that the practice of meditation

The main house at Dharma Rain hosts one of several tranquil public sitting areas.

seems to be strengthened and deepened by doing it in community and with some ritual attached. And if you haven't tried it, some instruction and support can be very helpful.

The ritual at Dharma Rain can be confusing, but the website offers helpful information, and if you show up a little early, someone can assist further—if you ask. I have a good friend who's very involved at Dharma Rain, and he told me before I first visited, "Don't worry about making mistakes. You'll make them, and it doesn't matter."

A good starter is to attend a workshop such as "Zen Meditation" or "Starting a Practice." Another is to come on Wednesday evenings, when there is a brief service, 30 minutes of sitting, and then a class. A larger service takes places on Sundays; there are also weekend and weeklong retreats and even a residency program.

But that's getting way ahead of yourself. If you haven't practiced meditation, give it a try. If nothing else, how often do you set aside time to simply sit with yourself and others, focusing on your breath, letting go of thoughts, and allowing peace to come to you?

The best way to find out what those folks are doing is to go do it with them.

⌣ essentials

⌑ 2539 SE Madison Street, Portland, OR 97214

ⓒ (503) 239-4846 ⓖ dharma-rain.org

$ Most events are free, small fees are charged for some events, and donations are always welcome. Membership fees run $10–$100 per month.

⏱ Closed Sunday noon–Tuesday noon; check calendar for specific events. **Sitting mediation (Zazen):** Sunday, 8:30 a.m. and 9:10 a.m.; Tuesday, 7 p.m. and 8:10 p.m.; Wednesday, 6:30 a.m. and 7:10 p.m.; Thursday–Saturday, 6 :30 a.m.; Friday, 7 p.m. **Slow walking meditation (Kinhin):** Sunday, 9 a.m.; Tuesday, 7:25 p.m. and 8 p.m. **Soto Zen Service:** Sunday, 9:40 a.m.; Wednesday–Friday (short), 7:30 a.m. **Chanting Service:** Tuesday, 8:30 p.m. **Dharani Chants:** Saturday, 7:30 a.m.; **Evening Service:** Wednesday, 7 p.m. **Vespers:** Wednesday, 9 p.m.; Friday, 7 p.m.

🚍 **TriMet Bus:** #14 to SE Hawthorne Street and 25th Avenue or #15 to SE Belmont Street and 26th Avenue

peaceful place 23

EAGLE CREEK HIKE
Mount Hood National Forest, Oregon (MAP 8)
CATEGORY ↵ day trips & overnights ✪ ✪

*W*henever I go to Eagle Creek, I expect to see fairies. It's really that magical: waterfalls plunging from all around into a lush, green canyon; a mountain stream rolling along at the base of vertical cliffs; a trail that seems suspended in midair.

For all these reasons, Eagle Creek is often quite *non*peaceful. Everyone who hikes at least once a year—and that's almost everyone—knows about it, and the trailhead on a summer weekend might make you think that there's a music festival going on.

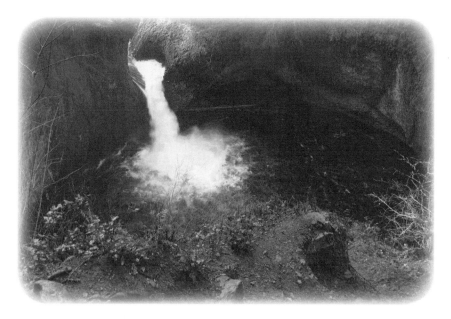

Punchbowl Falls lies just a couple of miles up Eagle Creek Trail.

Ah, but slip away on a weekday or sometime other than summer, and you'll likely encounter only a handful of other people. In fact, in October you'll see more spawning salmon than hikers. A couple more great things about this hike: it's easy, and the amazing scenery starts right away.

Two disclaimers: You may encounter snow and ice in winter, and there are times when this trail follows ledges blasted into the cliff face 100 feet or more above the creek. Although you'll usually find cables to hold on to in such areas, people have fallen to their deaths on this trail. So be careful—and leash your dogs.

The most popular destination is Punchbowl Falls, a little more than 2 miles up. The main trail looks down on it, and a side trail visits the base. Also look for a side trail about 1.5 miles up to view Metlako Falls. But the trail actually goes 14 miles to Wahtum Lake; the last of the waterfalls is about 6 miles up, immediately past Tunnel Falls, where the trail travels through a tunnel blasted into the wall.

It really doesn't matter how far you go up this trail; just go. And take your time. You'll be surrounded by loveliness.

essentials

⌨ From Portland, drive east on I-84 for 34 miles and take Exit 41/Eagle Creek. Go 0.2 mile, turn right, and drive 0.6 mile to the end of the road. **GPS coordinates:** N45° 38.192' W121° 55.168'

☎ (541) 308-1700

🌐 tinyurl.com/eaglecreekhike or portlandhikersfieldguide.org/wiki/eagle_creek_hike

$ A Northwest Forest Pass is required for admission ($5/day, $30/year); buy online at tinyurl.com/region6passes.

🕐 24/7; open year-round but may have snow and ice in winter

🚌 n/a

peaceful place 24

ECOTRUST BUILDING (JEAN VOLLUM NATURAL CAPITAL CENTER)

Pearl District, Central Portland (MAP 1)

CATEGORY ⌇ urban surprises ⭐ ⭐

*A*sk different folks their opinions of the Pearl District, and chances are that their answers will vary wildly. I come down firmly in the camp of admiration. Sure, it could use more affordable housing (though there is some), but the great advantages of cities are convenience, efficiency, and well-planned density, and the Pearl has all those things.

Plus, there's the sense of adaptation and sustainability. In the Pearl, you need look no further for that than the Ecotrust Building, officially known (to almost no one) as the Jean Vollum Natural Capital Center. Built in 1895, it housed a warehouse in railroad

Prime views of the Pearl District from the ecoroof

days and then trucking firms afterward. In 2001, Ecotrust reopened it as a monument to sustainability and set up headquarters on the second floor. Such architectural reuse demonstrates the nonprofit Ecotrust's mission: "to inspire fresh thinking that creates economic opportunity, social equity and environmental wellbeing."

The building itself is pretty remarkable, with bioswales (to transport storm runoff), Gold LEED (Leadership in Energy and Environmental Design) certification, energy efficiency, solar power, reclaimed materials, and an ecoroof. It's this last that you should check out.

I could tell you all about the amazing qualities of an ecoroof, but you can pick up a helpful *Jean Vollum Natural Capital Center Field Guide* at EcoTrust's second-floor reception desk. What I'll say instead is this: go into the ground floor, get a slice of pizza or a burrito or a cup of coffee, and carry your refreshment into the elevator up to the ecoroof. From there you'll get a sense of what makes the Pearl District cool, in my view anyway: a collection of apartments, condos, and shops; green parks; compact, walkable streets; and a streetcar.

View it all from this groovy old building, adapted to modern needs and setting a standard for a new way of doing things. That in itself is a calming thought.

✎ essentials

▤ 721 NW Ninth Avenue, Suite 200, Portland, OR 97209

✆ (503) 227-6225

⊕ ecotrust.org/ncc

$ Free self-guided tours (please return the field guide when finished); for a tour led by a LEED-certified guide, click "Learn More" on the website's home page.

🕐 **Ecotrust:** Monday–Friday, 8:30 a.m.–5:30 p.m. **Food shops:** Daily, 11 a.m.–9 p.m.

🚊 **Portland Streetcar:** NW 10th Avenue and Johnson Street
TriMet Bus: #17 to NW Ninth Avenue and Glisan Street

peaceful place 25

ELK ROCK ISLAND
Milwaukie, Oregon (MAP 4)
CATEGORY ↵ urban surprises ★ ★

Living in Portland, you may easily forget that the Willamette is a river.
I know that sounds odd, because what else would it be, but how often do you look at that body of water downtown and think about currents and drainages and riverbanks and islands? It seems like something you cross on the way to work, right?

Well, it's a *river*, and if you want to get a little glimpse of it in that form, head out to Elk Rock Island. First you have to find tiny Spring Park in Milwaukie. It's a nice-enough place, but follow the trail into the woods. Yes, you're headed for the riverbank. And when

A view upstream from Elk Rock Island, in the middle of the Willamette River

you get there, if the water is low enough, you can walk right out to the island—across a land bridge thought to be 40 million years old.

We're not just in town anymore, are we?

This little island had many owners before 1910 (one of them even built a dance hall on it) before its last private owner, a Scottish grain exporter named Peter Kerr, donated it to the city with one stipulation: "Preserve it as a pretty place for all to enjoy." Mission accomplished.

Here, within sight of homes and docks and industry, are a patch of woodlands, a small beach, a rocky bench, a cliff face, and a hidden lagoon. Here are hiking trails and picnic spots, some peace and quiet, and—in winter, anyway—a waterfall across the way.

And here, rolling along as it always has, is a river, with a gentle current and birds bobbing and swooping and, yes, an island in the middle of it.

↙ essentials

⌨ Land-bridge access from the trailhead at SE 19th Avenue and Sparrow Street, Milwaukie, OR 97222
GPS coordinates: N45° 26.156' W122° 38.881'

📞 (503) 823-7529

🌐 cyclotram.blogspot.com/2008/10/elk-rock-island-expedition.html or tinyurl.com/elkrockisland

$ Free

🕐 Daily, sunrise–sunset, but generally accessible only by boat in the high water of winter and spring. Boaters typically anchor on the island's west side.

🚌 n/a

peaceful place 26

ELK ROCK, THE GARDEN OF THE BISHOP'S CLOSE
Southwest Portland (MAP 5)
CATEGORY ༀ spiritual enclaves ✪ ✪ ✪

*I*t's surprise after surprise with this place.

First, there's the simple fact that it exists—I'll wager that at least 9 out of 10 Portlanders have never heard of it. And if you have, I'll bet you think that a garden at the Episcopal bishop's home sounds inaccessible and underwhelming. While the home itself is private, the nearly 100-year-old botanical garden around it offers multiple layers of soothing beauty for everyone.

In fact, the surprises start in the tiny parking lot, which, thankfully, is too small for buses. Look over by the wall—that's a wisteria so large that there's a bench beneath it! Now start down the path and notice the tiny rock trails leading up the hill; they lead to a parterre garden of narrow gravel paths and manicured hedges.

Follow a level path from the parterres out past the South Lawn to The Point, where you'll enjoy a cliff-top view of the Willamette River—a surprise in itself. How often have you looked straight down at the Willamette? And did you know that there's an island out there called Elk Rock? (See the previous profile for more on that peaceful spot.)

Following a loop around the edges, you'll come to a fish pond, a cascading water garden, countless benches for sitting and contemplating, a view of Mount Hood, and so on. But rather than read the specifics here, just go and be surprised on your own.

essentials

📧 11800 SW Military Lane, Portland, OR 97219

📞 (503) 636-5613, then press 6

🌐 elkrockgarden.com

$ Free for individuals; groups may arrange docent-led tours, for which donations are requested.

🕐 Daily, 8 a.m.–5 p.m.

🚌 **TriMet Bus:** #35 to SW Military Lane and Riverside Drive, about 0.2 mile away

peaceful place 27

EQUINOX RESTAURANT AND BAR

Boise, North Portland (MAP 2)

CATEGORY ⌣ quiet tables ⚫

*J*f you live in Portland, you probably know about what I call the Myth of the Brunch Lines. It states, inaccurately, that every place in town that serves brunch has a ridiculous wait.

In no place is this more apparent than on North Mississippi Avenue. True enough, on any given weekend the line at Gravy is down the block, but right around the corner, on Shaver Street, is an unassuming little eatery with a fine patio set off by brick walls and an iron gate. This is Equinox, and chances are that you won't find much of a line.

It also has the Breakfast Nook. Or Cave. Or Lair. It's a little space off the main dining room with room for barely seven people, and you can even close the curtains. It's the secret, quiet place within a secret, quiet place.

It doesn't serve only brunch, of course—that just happens to be my favorite meal—but at all times it has yummy food with fresh, local ingredients, served by a young, charming staff.

So if you eat here, especially in the morning, you might wonder what I always wonder: *What are those folks on Mississippi Avenue doing, waiting in line all day?*

⌣ essentials

830 North Shaver Street, Portland, OR 97227

(503) 460-3333

equinoxrestaurantpdx.com

Brunch: $10–$12. **Dinner:** $14–$20.

Happy hour: Monday–Friday, 4–6 p.m. **Dinner:** Nightly, starting at 5 p.m.
Saturday and Sunday brunch: 9 a.m.–2 p.m.

TriMet Bus: #4 to North Mississippi Avenue and Failing Street

peaceful place 28

FEHRENBACHER HOF

Goose Hollow, Southwest Portland (MAP 5)

CATEGORY ⌣ quiet tables ✪ ✪

*S*ometimes you're just in the Portland groove.

Let's say that you're having a work breakfast in a crowded diner and your next appointment is in Beaverton in a few hours. You mention to your breakfast companion that you need a place to kill some time, maybe a distraction-free place to get some work done. She says, "Take the MAX over to The Hof."

So you check online, walk a few steps, grab a bus to the MAX, and 15 minutes later you're looking at an old house in a quiet, tree-filled neighborhood, with a welcoming front porch where somebody's reading a book.

You step inside and grab a seat in the little back room, with three comfy chairs, a table in front of a church pew, and several windows open to the summer breeze. You log in to the fastest Wi-Fi known to man and think to yourself, *How long has* this *place been here?*

The unassuming Fehrenbacher Hof is great for a morning bite while you spend some quality time with your laptop.

The answer, it turns out, is since 2000, when it became part of the empire of former mayor Bud Clark, who also started the Goose Hollow Inn next door. The Fehrenbacher Hof, thankfully known simply as The Hof, is the early-morning soul-soother out back of the crowded inn, with six kinds of coffee, shelves full of teas and pastries, and half a dozen sandwich selections.

But back to that groove thing. You notice there's a lounge upstairs with more comfy chairs and a public computer. Then you check out their website, which says, "Please come in and sit for a bit while contemplating your next idea." And you think to yourself, "*Exactly!* Thanks, Portland!"

essentials

☰ 1225 SW 19th Avenue, Portland, OR 97205

☎ (503) 223-4493

🌐 tinyurl.com/thehof

$ $0.75–$6

🕐 Monday–Friday, 6 a.m.–6 p.m.; Saturday, 7 a.m.–6 p.m.; Sunday, 8 a.m.–6 p.m.

🚌 **MAX Light Rail:** Goose Hollow Station

peaceful place 29

FLOAT ON
Hawthorne, Southeast Portland (MAP 4)
CATEGORY ⌣ shops & services ✪ ✪ ✪

*R*emember sensory-deprivation chambers? They were really hot way back when the *Altered States* movie came out, and then faded away. Well, they're back, in southeast Portland, and the folks at Float On are borderline evangelistic about them.

Let's start with the basics: yes, you're in a completely dark chamber, floating in water so salty that it supports your weight completely. It takes some getting used to, but the staff walks you through it, and after a little while, there really is something very soothing about simply floating in darkness—no lights, no sounds, no gravity.

Float On's quiet lobby foretells more-tranquil times to come.

As for the claustrophobia factor, which was a concern of mine, two of the tanks are tall enough to stand up in, so request one of those if you're worried. It wasn't an issue for me at all, in particular because you control the light and the door.

You strip naked, take a quick shower, and sit down in about 10 inches of water. Lean back, and you float. Earplugs keep the water out, and even though you're right on Hawthorne Boulevard, you won't hear a thing. It's fascinating to observe both body and mind adjusting to complete relaxation; your neck and shoulders, in particular, take a while to realize that they don't have to hold up your head anymore. You'll notice tension in parts of your body that you've never even thought of before, and then feel it melting away.

From there, it's whatever you want it to be. The staff, programs, and literature suggest a cornucopia of benefits, from boosted theta brain waves to better golf scores.

All I can say is that once you get the hang of it and actually convince yourself that it's OK to relax and let go, it's an experience that's intense yet tranquil—and like nothing else you're ever likely to do.

essentials

4530 SE Hawthorne Boulevard, Portland, OR 97215

(503) 384-2620

floathq.com

$ 90 minutes, $50; 3.5 hours, $80; late-night 2.5 hours (Thursday–Friday, 11 p.m. or 2 a.m.), $60; check website for monthly pass rates.

Monday, 7 a.m.–11 p.m.; Tuesday–Wednesday and Sunday, 7 a.m.–1 a.m.; Thursday–Friday, 7 a.m.–5 a.m.

TriMet Bus: #14 to SE Hawthorne Boulevard and 44th Avenue

peaceful place 30

FORT VANCOUVER NATIONAL HISTORIC SITE

Vancouver, Washington (MAP 8)

CATEGORY ✧ historic sites ✪ ✪

I like Fort Vancouver. The buildings are nice, the demonstration of blacksmithing is interesting, and the archeological stuff is just fine.

What I *really* like, though, is to imagine. I stand up in the watchtower at the corner of the wall and look out over the Columbia, up into the gorge, and around at the hills. And I think about what it must have been like when, to the employees of Hudson's Bay Company who built and ran this place, everything beyond those walls was wilderness: wild, untamed, and largely unknown.

The fort may be a replica, but it still manages to take you back in time.

And then I think about this fact: the fort was first built on the hill for defensive purposes. However, after a while they realized that the local natives meant them no harm, so they settled down here on the plain and planted fruit and nut trees and a garden. Here, they founded the Northwest's first school, library, hospital, and other institutions. This was a village with 35 ethnic and tribal groups represented, and a fort whose guns were never fired in anger.

None of the original buildings survive, but historians are pretty sure that they're accurately rebuilt and in the right places. Some of the fruit trees, though, are still standing and still bearing. You can visit for any number of special events, such as lantern tours, archeological digs, plant talks, and re-creations of 19th-century games.

Living in the past gets a bad rap, I say. At least it does when the past was so interesting. The Portland area would hardly be called a wild, culturally diverse hinterland today, but if you go out to Fort Vancouver, slow down a little, and look at things with the right set of eyes, you can remember a time not too long ago when it was just that.

essentials

✉	1001 East Fifth Street, Vancouver, WA 98661
☎	(360) 816-6230
🌐	nps.gov/fova
$	Adults, $3; children age 15 and younger, free
🕐	Monday–Saturday, 9 a.m.–5 p.m.; Sunday, noon–5 p.m.
🚆	n/a

peaceful place 31

GRAHAM OAKS NATURE PARK
Wilsonville, Oregon (MAP 8)
CATEGORY ⌇ outdoor habitats ✪ ✪

*W*hen you arrive at Graham Oaks Nature Park, it's good to take the long view. For starters, you shouldn't expect to see a lot of oaks. The originals were cut down generations ago, and the future oaks are still seedlings.

The 150-year-old Legacy Oak

This wide-open space, almost jarring after driving through Wilsonville, was probably once an oak savanna covered with grasses, animals, and hunter-gatherers. Then came the 19th century and farmers, then the 20th century and some really bad ideas, then a wave of activism, and finally, in 2010, this sprawling space before you—at once a park, a reclamation site, a refuge, an experiment, and a laboratory.

But that's all the long view. In the short view, it's a lovely place to go for a walk, jog, or bike ride. It comprises 250 acres of forest, grasslands, and wetlands, with 3 miles of well-marked trails and

plenty of places to sit and take it all in. A discerning eye visiting frequently will notice changes as the wildflowers take root, more animals arrive, and the oaks get taller.

Ah yes, the oaks. Some 15,000 of them were planted, along with 135,000 other trees and bushes and something like 100 million wildflower and grass seeds. But there is one original oak you can visit, and it's pretty easy to spot. It's between 150 and 200 years old, atop the hill, with a bench next to it and a fence around it. An educational plaque explains all the ways an Oregon white oak benefits wildlife.

But mainly, this Legacy Oak, as it's called, gives us humans a reminder of what was, a vision of what will be, and a nice place to sit and admire what is.

essentials

11825 SW Wilsonville Road, Wilsonville, OR 97070

Metro Parks & Environmental Services: (503) 797-1850
City of Wilsonville: (503) 682-1011

tinyurl.com/grahamoaks (click "Download Park Brochure")

Free

Daily, 6:30 a.m.–sunset

Wilsonville SMART Bus: #4/Wilsonville Road from Wilsonville Station
WES Commuter Rail: Beaverton Transit Center to Wilsonville Station

peaceful place 32

THE GROTTO: THE NATIONAL SANCTUARY OF OUR SORROWFUL MOTHER

Rose City Park, Northeast Portland (MAP 3)

CATEGORY ⌣ spiritual enclaves ✪ ✪

*T*he best-known thing about The Grotto is also the least peaceful. Every winter, throngs of people flock there to see the Christmas Festival of Lights and attend a Christmas-themed service in the chapel. It's lovely and colorful . . . and also crowded and nuts. For a lovely, colorful, non-nuts experience, go back at some other time of year, plunk down $4 to take the elevator up the cliff, and roam the fantastic Upper Level Gardens.

It doesn't get more peaceful than a monastery.

As soon as you step out of the elevator, you'll see that this is a different place from the more touristy scene down on the Plaza Level. Here are 62 acres of greenery, with paths leading you past shrines surrounded by tall trees, ponds, and flowering shrubs. Every month of the year brings different blooms: flowering plums in March, trilliums in April, rhododendrons and azaleas in May, and impatiens and daisies in summer.

Of particular note are the Meditation Chapel, which offers a view of the Columbia River; the Peace Garden, with its waterways and ponds; and the new labyrinth, designed in 2010 in a wooded corner at the far end of the gardens. But the suggested experience here is to simply wander around.

It's funny to think of so much activity below—the gift shops, the chapel, the coffee shop, and the Christmas crowds—while there's so much green, quiet peace up above. Heavenly, you might say.

Note: Guided tours are available for groups of 10 people or more—a good idea provided everyone in your entourage is peaceful.

essentials

8840 NE Skidmore Street, Portland, OR 97220

(503) 254-7371

thegrotto.org

$ Plaza Level: Free. **Upper Level Gardens elevator token:** Adults and children ages 12–64, $4; seniors age 65 and older, $3; children ages 6–11, $2.50; children age 5 or younger, free. **Christmas Festival of Lights:** Adults and children age 12 and older, $8.50; children ages 3–12, $4; children age 2 and younger, free.

Daily, 9 a.m.–5:30 p.m. **Christmas Festival of Lights: Day after Thanksgiving–December 31:** Daily, 5–10 p.m. (grounds closed 4–5 p.m.)

TriMet Bus: #72 to NE Sandy Boulevard and 82nd Avenue or #12 to NE Sandy Boulevard and Grotto entrance

peaceful place 33

HANDS ON CAFE
Sylvan, Southwest Portland (MAP 5)
CATEGORY ⌣ quiet tables

his is no student cafeteria at the Oregon College of Art & Craft. The school itself embraces a hilly, wooded campus on the western slope of Forest Park. To visit this charming little café, you park in a shaded lot and wander down a

At Hands On Cafe, you'll have fresh flowers at your table—and perhaps new friends.

wooded path to a building with an art gallery, a gift shop, and the kind of dining hall you'd expect at an art school in the West Hills: a fireplace, art on the walls, flowers on the tables, jazz playing softly, and fresh homemade food.

Options are limited, and when you see the size of the kitchen, you'll know why. But the menu changes daily, based on what the Cook family (yep, that's their name) bought on the way in each day. They serve lunch and dinner cafeteria-style, while Sunday brunch features table service and a menu of four items, one of which is usually pancakes. When we visited,

it was buttermilk cakes topped with winter-fruit compote, crème anglaise, sweetened whipped cream, and toasted almonds. Mercy!

Try to visit in late spring or early summer, when those rhododendrons and azaleas flower and you can sit on the quiet little patio, surrounded by all those blooms—along with the long-awaited Oregon sun, the creativity, and the yummy food. *Mmmm.*

✔ essentials

⌨ 8245 SW Barnes Road, Portland, OR 97225

☎ (503) 297-1480

🌐 handsoncafepdx.com

$ **Lunch and dinner:** $4–$9. **Brunch:** $11–$12. *Note:* Cash or local checks only.

🕐 Monday–Friday, 11:30 a.m.–2 p.m. and 5:30–7:30 p.m.; Sunday, 9:30 a.m.–1:30 p.m.

🚌 **TriMet Bus:** #20 to Oregon College of Art and Craft

peaceful place 34

HEALING WATERS AND SACRED SPACES

Irvington, Northeast Portland (MAP 3)

CATEGORY ⌣ shops & services ✪ ✪ ✪

*N*ew Age usually gets classified as an alternative philosophy. What it's an alternative to is debatable, but let's assume that it's an alternative to the usual Western, capitalist, Judeo-Christian, materialistic way of seeing and doing things.

Healing Waters abounds with supplies for your spiritual needs.

Nonetheless, this alternative worldview involves some shopping, including herbs, crystals, prayer wheels and flags, Buddha statues, and "botanical products infused with energetic frequencies." And for that there is Healing Waters and Sacred Spaces.

The healing waters, in this case, are a line of scrubs, salts, and oils created by "an energy healer, intuitive alchemist, aromatherapist, body worker, and sound healer." Or maybe the water flowing from a fountain in the form of an Eastern deity. The store is also known for its wide selection of crystals and Nepalese statues. A reader and healer, on premises most days, works out of a private room in the back.

But most interesting is the event space around the corner from the retail space; it hosts monthly and special events, including a weekly drop-in meditation group on Thursdays as well as a Tuesday Deeksha meditation group. According to the store's website, Deeksha is "a hands-on transfer of energy from higher consciousness given with a light touch upon the top of the head."

A pretty tranquil alternative, I'd say.

essentials

⌨ 2426 NE Broadway, Portland, OR 97232

☎ (503) 528-1430

🌐 livingsacred.com

$ Prices vary widely ($16–$33,000); check website for details.

🕐 Monday–Friday, 11 a.m.–7 p.m.; Saturday, 11 a.m.–6 p.m.; Sunday, noon–5 p.m.

🚌 **TriMet Bus:** #9 to NE Broadway and 24th Avenue or
#77 to NE Weidler Street and 24th Avenue

peaceful place 35

HEATHMAN HOTEL LIBRARY
Downtown, Central Portland (MAP 1)
CATEGORY ༝ reading rooms ⭐ ⭐ ⭐

*I*n all the old-fashioned splendor that is the Heathman Hotel, you might hardly notice the library above the tearoom. And even if you did, you'd probably think, *Wow, a seating area with some books.*

The Heathman library is stocked with books written by authors who have stayed at the hotel. (The hotel is also a key setting in one of the fastest-selling books of all time.)

But what you probably don't know about those books is that all are signed by authors who have spent the night at the Heathman. And they're not just for display: guests can check them out, although a few of the real treasures have to be read in the library.

They've been collecting books at the Heathman since the 1980s, and an estimated five authors a week spend a night there. Some of the big names with signed (usually first) editions on the shelves include—in alphabetical order, to show no favoritism—Jimmy Carter, Bill Clinton, Annie Dillard, Stephen King, James Patterson, Ian

Rankin, and John Updike. (Speaking of books, the hotel also figures prominently in E. L. James's runaway best seller *Fifty Shades of Grey.*)

The hotel opened the library in 1992 and in 2010 added staff to run it. Monday–Thursday, around 5:30 p.m., a little crowd gathers in the library for wine tastings, stories, and book viewings. About 2,000 volumes are on display in a 20-foot lineup of oak bookcases.

You don't have to be a guest to drop in and look around, although you do have to stay here to get in on the wine tastings or check out something on the shelf. And yes, I *am* saving my nickels to get a room!

essentials

✉	1001 SW Broadway, Portland, OR 97205
☎	(503) 241-4100
🌐	portlandlibrary.heathmanhotel.com
$	Free
🕐	n/a
🚈	**Portland Streetcar:** SW 11th Avenue and Taylor Street **MAX Light Rail:** Any line to Pioneer Courthouse Square

peaceful place 36

HISTORIC COLUMBIA RIVER HIGHWAY STATE TRAIL

Hood River, Oregon (MAP 8)

CATEGORY ↙ day trips & overnights ✪

*T*here is a point, somewhat vague, in the Columbia River Gorge where you've left the rain forest and entered the open grassland, headed for desert. In the grand scheme, it seems gradual . . . unless you're ambling out of the Mosier Twin Tunnels on the Historic Columbia River Highway State Trail—once a road, now a path for hikers and bikers.

A view over the Columbia at the Mosier (east) end of the highway, just east of the tunnels

Then it seems to have happened all at once, at the end of a lovely, easy stroll with a historical oddity at the end.

Speaking of history, this old road was a scenic engineering marvel when it was completed in 1922. But by the 1960s, I-84 had pretty much replaced it, and these tunnels were filled with rock. When the rock was removed in the 1980s to restore the road for its present purpose, your historical oddity was discovered: 1921 graffiti from a snowbound party of would-be campers, carved into the wall.

From the eastern trailhead in Mosier, it's 1.5 miles to the tunnels. But it's better (and slightly closer to Portland) to start at the western end in Hood River. From there, it's 3.5 winding, paved miles through a lovely forest (particularly beautiful in autumn, when the bigleaf maples put on their show) to the tunnels, which have a combined length of 493 feet. Inside, you'll find the graffiti and, on the eastern side, a sweeping view of the Columbia River, with a grassy area for a picnic.

You'll be interested to note some other restored sections of the old road, most notably between Eagle Creek (see the Eagle Creek Hike, page 46) and Locks, but much of that is way too close to I-84 to be very enjoyable. Besides, Hood River is worth a day trip all to itself. So while you're out there, take a little stroll into the past, on the old road between forest and desert.

⌣ essentials

Mosier (east) trailhead: From Portland, drive east on I-84 about 95 miles to Exit 69/ Mosier. Turn right off the exit, and then take the first left onto Rock Creek Road. Go under the railroad tracks and continue for less than 1 mile. The parking area is on your left; the trailhead is across the road. **GPS coordinates:** N45° 41.096' W121° 24.276'

Hood River (west) trailhead: From Portland, drive east on I-84 about 90 miles to Exit 64/OR 35. Turn right off the exit, and then take the first left onto Old US 30/Old Columbia River Drive—look for China Gorge Restaurant at the intersection—and continue about 1 mile to the Twin Tunnels Visitor Center and the parking area, on your left. The trail begins where Old Columbia River Drive ends. **GPS coordinates:** N45° 42.180' W121° 29.220'

☏ (800) 551-6949

🌐 oregonstateparks.org/park_155.php

$ **Use fee:** $5/day, $30/year, or $50/two years. Self-service machines at the trailheads dispense day passes; for annual/biannual passes, call the phone number above or visit tinyurl.com/dayuse-permit-vendors.

🕐 Daily, sunrise–sunset

🚍 n/a

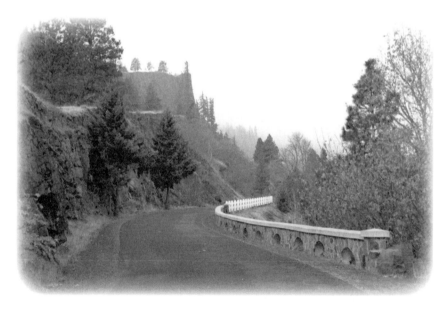

The Historic Columbia River Highway State Trail carves a swath through an autumnal forest.

peaceful place 37

HOWELL TERRITORIAL PARK

Sauvie Island, Outer Northwest Portland (MAP 7)

CATEGORY ⌣ historic sites ✪ ✪

*A*t first, in my ignorance, I confess that I expected more from Howell Territorial Park. I thought that it would be a sprawling place with trails to hike, a gift shop, and so on. But when we got there, my friend and I looked around and said, "Oh, it's just an old house."

Well, no, it isn't. First, the Bybee-Howell House is a fully restored 1856 farmhouse. For perspective, that's three years before Oregon became a state, and a time when Portland had maybe 1,000 residents. It would have been a lengthy trip to get out here back then.

The Pioneer Orchard at Howell Territorial Park is composed of trees planted from very old seeds.

The house isn't currently open to the public, but it's not the main attraction here anyway. The grounds around it make a beautiful place to picnic, and in fact both the yard and the fir grove can be reserved through Metro. But most days that won't be necessary.

Simply stop off at one of the many fruit stands or you-pick places on Sauvie Island, and then come to Howell Territorial Park to get away from the crowds and the sun. Grab a table out back and take a walk through the Pioneer Orchard; although it was planted in 1970, the trees all came from stock that was either brought across the frontier by wagon or shipped around Cape Horn—or both.

Then relax, let your mind drift into the past, and think of all the other picnics, parties, and gatherings that must have happened here over the years. Not just an old house anymore, is it?

essentials

13999 NW Howell Park Road, Sauvie Island, Portland, OR 97231

For general info, call Metro Parks & Environmental Services, (503) 797-1850; to reserve a picnic table, call (503) 665-4495.

tinyurl.com/howellpark or tinyurl.com/howellpicnic (for picnic info)

Free to visit. **Picnic reservations:** $225 for five hours, $55 each additional hour.

Daily, sunrise–sunset. Reserve picnic areas on weekends Memorial Day–Labor Day.

TriMet Bus: #17 to NW Sauvie Island and Gillihan Roads (last stop on the route), 1 mile away

peaceful place 38

HOYT ARBORETUM

West Hills, Southwest Portland (MAP 5)

CATEGORY ↵ enchanting walks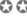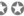

*T*he word is so scientific: *arboretum*. It sounds like a newfangled display at a World's Fair 100 years ago. And, in fact, it means "tree museum," which itself sounds stuffy and display-filled.

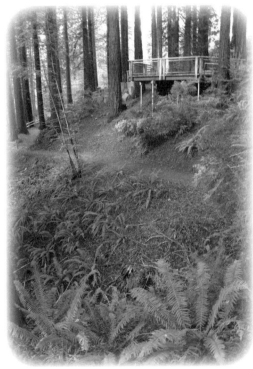

A viewing deck was recently built among Hoyt Arboretum's sequoias.

So let's go to the heart of what an arboretum is. It's a refuge for trees, people, and other forms of life. It's a promise to future generations. It's an orderly, organized place where the abundance and chaos of nature are given space to spread out a little, with just enough human logic to plan a visit: cherry trees here, maples there, spruces over yonder.

A little more on the specific side, Hoyt Arboretum is 12 miles of trails winding through 187 acres of trees atop a ridge in the middle of the city. Starting in 1928, it was planted as an educational and conservational tool, and today its

brochures like to call it a "living laboratory," filled with 8,000 trees of more than 1,000 species.

Go to the Visitor Center and grab a brochure so you won't get lost, but also for a list of what is blooming when, and other seasonal highlights. In winter, find fragrances in the Winter Garden or berries along the Holly Trail. Spring means cherries, magnolias, winter hazels, and dogwoods. Summer means shade. Fall means color, especially the Japanese larch—a rare deciduous conifer.

Whenever you go, remember to not get too hung up on making a plan. Sure, there's a particular plant you want to see. You'll also want to take a breath, slow down, and simply be with the trees.

↙ essentials

▣ 4000 SW Fairview Boulevard, Portland, OR 97221

Ⓒ (503) 865-8733

⊕ hoytarboretum.org

$ Free

◔ **Grounds:** Daily, 6 a.m.–10 p.m. **Visitor Center:** Monday–Friday, 9 a.m.–4 p.m.; Saturday, 9 a.m.–3 p.m. Closed major holidays.

🚌 **MAX Light Rail:** Red or Blue Line to Washington Park Station

peaceful place 39

THE JASMINE PEARL TEA MERCHANTS

Kerns, Northeast Portland (MAP 3)

CATEGORY ↳ shops & services ✪ ✪ ✪

*E*ntering the world of tea is a little like looking through a simple window and seeing an immense, spectacular place that seems to go on forever. Maybe that "door" is Earl Grey, and when you look into it, you find out that you can get Earl Grey with lavender. "Mmmm," you say, "what else is there?"

And then you're off into the world of blacks, whites, greens, oolongs, pu-erhs, and herbals. It's an amazingly varied, historic, multicultural, delicious adventure.

Shelves of pu-erh tea compose just some of The Jasmine Pearl's wide-ranging inventory.

The folks at The Jasmine Pearl are "deeply in love with tea," according to its website. That same site also has a tea school with tips on brewing, and if you wander into the charming little shop, the staff will offer this same expertise along with a taste of any tea they carry. You can even arrange a private tasting. They sell dozens of kinds of teas, as well as merchandise from elegant tea sets to a "Pot Head" (get it?) T-shirt.

It's a relaxing and tranquil little shop in an otherwise-bleak neighborhood, and to wander

in is to enter the world of the tea lover. They'll teach you about tea—how to brew it, how it's good for your health, where it comes from, and how it's blended. They'll pour you a lovely cup. And they'll be glad to send you home a little more relaxed, with some new knowledge and something yummy to take with you.

essentials

724 NE 22nd Avenue, Portland, OR 97232

(503) 236-3539

thejasminepearl.com

Free to browse; teas about $2–$9 per ounce

Monday–Friday, 10 a.m.–6 p.m.; Saturday, 11 a.m.–5 p.m.

TriMet Bus: #9 or #77 to NE 21st Avenue and Weidler Street, #33 to NE 21st Avenue and Clackamas Street, or #12 to NE 24th Avenue and Sandy Boulevard

peaceful place 40

JOHN STREET CAFE
St. Johns, North Portland (MAP 2)
CATEGORY ⌣ quiet tables ★

*T*here are lots of reasons why a restaurant might succeed, including good food, nice atmosphere, convenient location, and pleasant staff. All of those apply to the John Street Cafe. But unless you've been there, this café has a secret that you might not know about.

The owner of the John Street used to own the Tabor Hill Cafe on Southeast Hawthorne (now to be avoided), and when he moved to North Portland, his customers came along. That's because he keeps the food and the options simple: a one-page breakfast-and-lunch menu offering big portions of down-home classics. You want old school? He doesn't even have a website!

Make sure, when you come in, to ask about the coffee cake and the pancakes. Both are rotating specials. The coffee cake varieties include huckleberry-blueberry, and I once had a filbert-and-currant pancake that was as big as the plate and that still sets my personal standard for pancakes: crispy outside and tender inside. This hangout is also known for its oatmeal, which comes with your choice of dried raisins, currants, apricots, or cranberries and chopped filberts or walnuts.

But the café also has a wonderful secret: the back patio. It's a seating area with picnic tables ringed by beds of fuchsias, bleeding hearts, columbines, geraniums, creeping phlox, Japanese maples, and bamboo. Dogs, welcome on the patio, sit curled up beside picnic tables filled with families. An enormous fig tree looms overhead, providing shade, as well as fruit in September.

John Street does get crowded, and it would be a hassle for a group of six or more. But if you can make it early and get a seat outside, you might feel as though you're having a tasty picnic with old friends.

⌣ essentials

✉	8338 North Lombard Street, Portland, OR 97203
✆	(503) 247-1066
🌐	n/a
$	$4–$11
🕐	Wednesday–Friday, 7 a.m.–2:30 p.m.; Saturday, 7:30 a.m.–2:30 p.m.; Sunday (breakfast only), 7:30 a.m.–2:30 p.m.
🚌	**TriMet Bus:** #4 to North Lombard and Charleston Streets, or #17 or #75 to North Lombard and John Streets

peaceful place 41

KELLEY POINT PARK

St. Johns, North Portland (MAP 2)

CATEGORY ⌇ scenic vistas ✪ ✪

*Y*ears ago, I had the occasion to climb a mountain with a guide named Jack Turner. He turned out later to become mildly famous as the author of several books, but he said one thing on our climb that has always stayed with me: "I measure my happiness by how far I can see."

Kelley Point Park offers sweeping vistas of the Columbia and Willamette Rivers.

I remembered that line when I walked out onto the beach at the point where the Willamette River joins the Columbia. Under a massive blue sky dotted with clouds, with water spreading in a 180-degree span before me, I could see far. A few lines of trees appeared thin in the distance.

I was at Kelley Point Park, which on summer weekends is a very popular picnic spot but otherwise offers a chance to roam both beach and trail in near solitude. At the point itself, you'll find a couple of tables, an old anchor stuck in the sand, a series of pilings usually hosting

herons or cormorants or gulls, and a whole lot of water and sky. You can see a really long way, in other words.

But with a different kind of vision, you can see from Oregon to Alberta, Montana, Nevada, and Wyoming. Those places are where all this water comes from: to your left is the Willamette, which drains more than 11,000 square miles of Oregon along its 187 miles of length. To your right is the Columbia, the great river of the Northwest, 1,243 miles of water that drains an area the size of France. The water at your feet may have been snow in the Canadian Rockies, on the west slope of the Grand Tetons, or on our own Three Sisters.

Now *that's* a long way.

⌣ essentials

	North Marine Drive and Lombard Street, Portland, OR 97203 **GPS coordinates:** N45° 38.757' W122° 45.844'
ℂ	(503) 823-7529
🌐	tinyurl.com/kelleypointpark
$	Free
🕐	Daily, 6 a.m.–9 p.m.
🚌	n/a

peaceful place 42

LAN SU CHINESE GARDEN

Old Town, Central Portland (MAP 1)

CATEGORY ↙: parks & gardens ✪ ✪

" *W* hichever way you go is the right way."

That's the pearl of wisdom we were handed as we entered Lan Su Chinese Garden. A volunteer said it to us as a matter of direction, or perhaps reassurance. It also captures something of ancient Chinese philosophy: that there is only one Way, that it exists before choice, and that the path to peace is releasing into the Way.

This little waterfall is one of many hidden treasures at Lan Su Chinese Garden.

And so there is no *one way* to visit this little island of tranquility in the middle of Old Town—although free tours, plus occasional concerts or classes in Tai Chi or calligraphy, take place throughout the day. Modeled after the 16th-century estate of a government official and scholar, and made largely of Chinese materials and by Chinese artisans, the garden invites you to wander its courtyards, pagodas, paths, doorways, and water features, even a teahouse.

photographed by Roman Dominguez

So it's not a garden in the Western sense, or even in that of the Japanese: rather than plants, there are features, in places where you can simply be. For example, there is one central pond, but there is seemingly an endless number of scenes from which to admire it. The variety of views and locations in one city block is amazing. And just let some of the names flow over you: Courtyard of Tranquility, Knowing the Fish Pavilion, Reflections in Clear Ripples, Flowers Bathing in Spring Rain, Painted Boat in Misty Rain, and Tower of Cosmic Reflections.

Walking in here, especially during the week, and maybe in a light rain, you leave the city behind and go out in the country of a long time ago. It also gives you permission to find your own "right way."

✓ essentials

✉	239 NW Everett Street, Portland, OR 97209
✆	(503) 228-8131
🌐	portlandchinesegarden.org
$	Adults, $9.50; seniors age 62 and older, $8.50; students ages 6–18 and college students with ID, $7; families, $28; children age 5 and younger, free
🕐	**November 1–March 31:** Daily, 10 a.m.–5 p.m. **April 1–October 31:** Daily, 10 a.m.–6 p.m.
🚃	**MAX Light Rail:** Old Town/Chinatown **TriMet Bus:** #4, #8, #16, #35, #44, or #77 to NW Everett and Second Streets

peaceful place 43

LEACH BOTANICAL GARDEN
Lents, Southeast Portland (MAP 4)
CATEGORY ᵕ parks & gardens ✪ ✪ ✪

*O*ne way to look at Leach Botanical Garden is that it's a beautiful little piece of creek-side nature a couple of minutes from the mundanity of the Pick-n-Pull auto-parts store. In that respect alone, it's remarkable. That so few Portlanders seem to know of its existence adds a certain air of discovery to your first trip.

Walk around its pleasant paths, and you'll find yourself surrounded by several gardens in one. You will come to a native-plant collection, then to a historical collection, and

A cottage on the grounds of the former Leach estate

then one designed to simulate different ecosystems around the Northwest. Continue on and you'll spot plants from the Southeast, a camellia collection, and a fern collection.

At the bottom of the hill is Johnson Creek, which offers yet another surprise. Did you know that this 26-mile-long creek has salmon and steelhead runs? Right here in the city, no less.

But what really strikes me about the place is that it still feels like a home we're allowed to visit. In fact, the owners, John and Lilla Leach, left the place to the city. John was a druggist and Lilla a botanist; both were the grandchildren of Oregon Trail pioneers. They bought the land in the 1930s, built a stone cabin and later a larger home (the Manor House), and named the property Sleepy Hollow. After they died, he in 1972 and she in 1980, the place became Portland's—ours.

I think you'll find it easy to feel like the Leaches' guests as you stroll through the woods, sit by the creek, and enjoy visiting their home.

☙ essentials

▤ 6704 SE 122nd Avenue, Portland, OR 97236

✆ (503) 823-9503

🌐 leachgarden.org

$ Free during regular garden hours; donations welcome

🕐 Tuesday–Saturday, 9 a.m.–4 p.m.; Sunday, 1–4 p.m. Closed January 1, Easter, July 4, Thanksgiving, and December 25

🚌 **TriMet Bus:** #10 or #71 to SE 122nd Avenue and Foster Street

peaceful place 44

LEWIS AND CLARK STATE RECREATION SITE
Troutdale, Oregon (MAP 8)
CATEGORY ᴗ: historic sites ✪ ✪

*L*et us pause to appreciate the Sandy River, for not every major city has a glacial mountain stream running through its suburbs. The water flows from the slopes of Mount Hood, winds through canyons and forests, hosts migrating salmon and steelhead, and 56 miles later spreads out into a tree- and meadow-filled delta before emptying into the Columbia River. The Sandy got its name—originally the Quicksand—from Meriwether Lewis and William Clark themselves, who camped here on November 3, 1805, noting "emence quantitys of sand" at the river's mouth.

This meadow was once the site of a pioneer homestead.

Lewis and Clark State Recreation Site has two main sections. Upstream (south) of I-84 you will find a popular swimming hole, a boat dock, and a rock-climbing area. What we're after, though, is the magnificent delta lying north of the interstate; you've seen one of its great meadows every time you've driven out I-84 into the gorge. But unless you've been out here, you have no idea what's available.

Actually, I should say "unless you have a dog," for this is doggie heaven. Roads and trails crisscross 1,400 acres of woods, forest, creeks, and (in the winter and spring) ponds and mud puddles. And there are dogs off-leash everywhere. In fact, I felt weird and out of place for not bringing a dog along.

I won't even bother telling you which trail to take, since they're all fine and just about the same, although it is worth your while to make your way out to the Sandy River. Once there, see if you can spot trees that have been gnawed on by beavers. But understand that you won't get there with dry feet anytime between November and May, when water levels are at their highest. Also check for a bird blind and pieces of artwork along the Columbia.

Lewis and Clark is a big old maze of places to go, for a picnic or a bike ride or a game of fetch. And if you're in the right frame of mind, you just might see it through the eyes of an explorer looking for a place to camp.

↙ essentials

▤	1 Jordan Road, Troutdale, OR 97060
☏	(800) 551-6949
☝	oregonstateparks.org/park_159.php or groups.yahoo.com/group/srd_mud
$	Free
☽	Daily, sunrise–sunset
⛟	n/a

peaceful place 45

LONE FIR PIONEER CEMETERY
Buckman, Southeast Portland (MAP 4)
CATEGORY ⌣ historic sites ⭐ ⭐ ⭐

*L*est we forget that our city used to be a little river town—and that what's now called southeast Portland used to be out in the country—let's go back to 1866.

In that year, Portland consisted of a few thousand people on the west side of the Willamette River. What is now the corner of SE 20th Avenue and Stark Street had recently been converted from the Stephens Farm to a cemetery, and the owner wanted to sell it to the city. But it was deemed too far from town, especially since Portland had yet to build bridges or pave streets.

This bigleaf maple is one of three Portland Heritage Trees in Lone Fir Cemetery.

In those days, this was a hill with one single fir tree, and probably a sweeping view of farmland in all directions. Think of how quiet and out of the way that would have been. Well, it still feels like that.

Perhaps the best way to visit this serene place is to admire the other trees that have grown around that fir. Three of them are Portland Heritage Trees. The first is a bigleaf maple dedicated to Oregon's first governor; it's over by the soldier's memorial. Turn toward Stark Street from there, then left before the fence, and look for an incense cedar on the right plus a gigantic western red cedar on the left.

The grave markers range from simple, falling apart stones to newer ones with photographs on them. You may also see a firemen's memorial among four cedars, some markers with Chinese characters, and some you can't even read.

And in the far northwest corner, still looking out over the country toward town, is the Lone Fir itself. A plaque identifies it. And if you look with just the right set of eyes, maybe you can still see that serene, rolling farmland.

⌣ essentials

Entrance on SE 26th Avenue, between Morrison and Stark Streets, Portland, OR 97214
GPS coordinates: N45° 31.088' W122° 38.351'

(503) 797-1709

tinyurl.com/lonefircemetery or friendsoflonefircemetery.org

$ Free

Daily, sunrise–sunset; no dogs allowed

TriMet Bus: #15 to SE 26th Avenue and Belmont Street or
#20 to SE 24th Avenue and East Burnside Street

peaceful place 46

MACLEAY TRAIL

Forest Park, Northwest Portland (MAP 6)

CATEGORY ∿: enchanting walks ⭐ ⭐

*Y*ou're right in the middle of town. Keep that in mind as you stroll along serene Balch Creek, admiring large trees, looking for fish, and listening to birds. Also keep this in mind: the trail you're walking is connected to some 80 miles of paths in Forest Park.

The Macleay Trail visits some of the few remaining old-growth trees in Forest Park.

You may also take a moment to thank a man named Donald Macleay. In 1897, he gave this land to the city, in part because he was annoyed that he had to pay taxes on it. According to legend, he said that he'd rather just hand it over, and the assessor said, "Well, why don't you?" Three days later, he did, on one condition: that the land become a park with trails wide enough for wheelchairs, so that hospital patients could enjoy it.

Today we have a wide path that is paved for the first 0.5 mile and surrounded by some very rare in-town old-growth forest. In fact, the tallest tree in the

city—some say the tallest in any major U.S. city—is a 243-foot-tall Douglas-fir, about 0.4 mile up and marked with a plaque. In 1987, the Oregon Department of Fish and Game discovered a native population of cutthroat trout living in a tiny stream, one of only two in Forest Park that flow year-round.

The trail is flat and easy along the creek, passing an old bathroom now called the Stone House, where you join the Wildwood Trail, which runs 31 miles through the park. If you put in a total of 1.1 miles with a little climb, you can reach the Audubon Society of Portland (see page 5). But you might decide instead to simply relax, explore, and be grateful for this gift to the city.

⌣ essentials

🖃	Macleay Park (part of Forest Park), NW 29th Avenue at NW Upshur Street, Portland, OR 97210; **GPS coordinates:** N45° 31.769' W122° 43.249'
✆	(503) 823-7529
🌐	tinyurl.com/macleaypark or portlandhikersfieldguide.org/wiki/forest_park_trails
$	Free
🕐	Daily, 5 a.m.–10 p.m.
🚌	**TriMet Bus:** #15 to NW 28th Avenue and Thurman Street

peaceful place 47

MAPLE TRAIL

Forest Park, Northwest Portland (MAP 6)

CATEGORY ↵ enchanting walks ✪ ✪ ✪

f you were looking for a downside to hiking in Forest Park, you could say that it lacks variety. That's because most of it was logged in the 19th century, so it has nowhere near the variety of trees found at, say, Mount Hood. You could also

The Maple Trail wanders through some of the prettiest, most serene parts of Forest Park.

possibly make the argument that it's somewhat crowded. It is, after all, in the middle of a major city.

Fortunately, neither of those things is true of the Maple Trail.

It constitutes only 4 of the 80 trail miles in the 5,000-acre park, but the Maple Trail is far enough from the neighborhoods of northwest Portland, and just enough of a pain to drive to, that relatively few people go there.

A walk on the Maple Trail includes everything that makes Forest Park a treasure: a nice trail winding in and out of wooded ravines, passing both new and old forest, crossing

creeks, and offering shade and sun, as well as being a generally easy hike (the trail gains only 350 feet in elevation over 4 miles).

The Maple is also connected to other trails as well as the less-traveled midsection of Leif Erikson Drive (see page 111) and the 31-mile, park-crossing Wildwood Trail. So you can loop around, explore, and maybe even sit awhile and listen to the birds. If it isn't a sunny weekend day, you may very well have the trail to yourself.

Get a good map because there are some confusing junctions here and many options. The best maps are in a little cardboard box courtesy of the Forest Park Conservancy; one of those covers the Maple Loop. There's also a Green Trails map of the entire park.

But do go. Be thankful for the solitude, for a chance to slow down, and for time to look for all the various forms of beauty along the way.

↶ essentials

⌸ End of lower NW Saltzman Road, Portland, OR 97210
 GPS coordinates: N45° 33.995' W122° 45.216'

☎ (503) 823-7529

🌐 tinyurl.com/forestparktrails, forestparkconservancy.org, or
 portlandhikersfieldguide.org/wiki/forest_park_trails

$ Free

🕐 Daily, 5 a.m.–10 p.m.

🚌 **TriMet Bus:** #17 to NW Saltzman and St. Helens Roads, and then walk 0.7 mile up Saltzman

peaceful place 48

MARQUAM NATURE PARK
Bridlemile, Southwest Portland (MAP 5)
CATEGORY ⌇ enchanting walks ✪ ✪ ✪

*E*very now and then, a small group of people makes a big difference for a really large group of people. As a member of this large group, you should feel grateful to the six people who founded the Friends of Marquam Nature Park back in 1968, to stop the construction of an apartment complex in a wooded area called Marquam Gulch.

Thanks to them, and many volunteers, funders, and activists since, there are now 176 acres of undeveloped land, and 5 miles of hiking trails, literally on the edge of downtown Portland.

Amphitheater in Marquam Nature Park

To explore this little wonderland, park at the shelter, where you'll find interpretive signs about the local plants and critters. You can also read about the 4T Trail (a combination of trail, tram, trolley, and train) and the 40-Mile Loop (actually more like 140 miles) as you wind around through the trees and ravines and over little creeks here and there. You can even take the trail all the way up 1.7 miles (and 740 feet) to Council Crest Park (see page 40).

But to take it easy, grab a brochure for a self-guided tour at the shelter and walk the 1.2-mile Shelter Loop, with points along the way to learn about the forest. Or sit among the rhododendrons around the shelter and think about how close you are to the middle of a city with more than a million residents. And to say thanks to those six neighbors who banded together more than 40 years ago.

◡ː essentials

✉	SW Marquam Street and SW Sam Jackson Park Road, Portland, OR 97201 **GPS coordinates:** N45° 29.821' W122° 41.629'
✆	(503) 823-7529
☀	tinyurl.com/marquamnaturepark or fmnp.org
$	Free
☼	Daily, 5 a.m.–midnight
🚌	**TriMet Bus:** #8 to SW Terwilliger Boulevard and SW Sam Jackson Park Road

peaceful place 49

McLOUGHLIN PROMENADE

Oregon City, Oregon (MAP 4)

CATEGORY ⌁ historic sites ✪ ✪ ✪

*L*et's go back in time a little. The year 1829: Hudson's Bay Company founds Oregon City. The year 1844: John McLoughlin buys this land. The year 1845: Oregon City becomes the first incorporated American city west of the Rockies. The year 1851: McLoughlin donates land along the bluff for a park.

When you stand out on the McLoughlin Promenade today, you're looking at the original destination of the 2,000-mile-long Oregon Trail, traveled by some 400,000 people in the 1830s and 1840s, though not all of them came all this way. As you look

Sit and contemplate history and industry on the McLoughlin Promenade.

at the view from here, see if, for just a second, you can see Willamette Falls, without the paper mills, as those families would have dreamed about seeing for months as they slogged across the continent.

Another bit of history: During the Great Depression the Works Progress Administration laid this concrete, and in 2010 the U.S. government fixed it up again. Now it can be what McLoughlin himself probably envisioned: a scenic place for folks to take a walk and look out over Oregon's first city. We also now have rhododendrons, park benches, historical plaques, and a paved walkway.

And we still have the falls—and the history as well. That history feels pretty alive when you're up on the promenade.

essentials

☰ Reach the promenade via the Oregon City Municipal Elevator, 300 Seventh Street, Oregon City, OR 97045.

☎ (503) 657-0891

🌐 orcity.org/publicworks/mcloughlin-promenade

$ Free

🕐 Daily, 5 a.m.–10 p.m.

🚌 **TriMet Bus:** #33 to Fifth Avenue and High Street

peaceful place 50

METROVINO

Pearl District, Central Portland (MAP 1)

CATEGORY ∿ quiet tables ⭐

*M*ention Metrovino to most Portlanders, and they say something about its state-of-the-art wine-storage facilities, which allow the restaurant to offer more than 80 wines by the glass—which in turns means that the crowd it attracts tends to be a little more sophisticated than that of, say, a brewpub.

And yes, that means the prices are above brewpub level as well. Entrées run a little north of $20, although a happy-hour and bar menu both run a little cheaper.

So it's classy, it has a great a wine-and-cocktail list, and it's in the Pearl. Are you thinking "stuffy"? OK, think about this: you're sitting in a booth by a window, in a quiet

The booths at Metrovino offer views of another peaceful place: Tanner Springs Park (see page 161).

corner away from the bar, and across the street is a park with tall grasses, flowers, a babbling brook, and a pond. Or you're outside facing a quiet apartment building, with no other businesses around, and perhaps a streetcar rumbling by. And all the while, you're eating something like a salad of ginger-marinated grilled lamb shoulder, or a grilled maple-brined pork chop with Tuscan white beans, butter-braised chard, onion rings, and herb aioli.

It's the quiet end of the Pearl District, away from the Burnside traffic and the loud restaurants and the parking hassles. From the outside tables you can even catch a sunset view in the summer. And inside there's no loud music, no false attempts to create a vibe, and generally not much of a crowd. It's just good food and service, with more than one option for a nice view.

essentials

☑ 1139 NW 11th Avenue, Portland, OR 97209

☎ (503) 517-7778

🌐 metrovinopdx.com

$ **Entrées:** $15–$28

🕐 **Happy hour:** Monday–Saturday, 4–6 p.m.
Dinner: Monday–Saturday, starting at 5:30 p.m.

🚍 **Portland Streetcar:** NW 10th Avenue and Northrup Street
TriMet Bus: #77 to NW 10th Avenue and Northrup Street

peaceful place 51

MOUNT TABOR PARK

Mount Tabor, Southeast Portland (MAP 4)

CATEGORY ⤳ scenic vistas ✪

*W*here do I start with Mount Tabor? If you live in Portland, you certainly know about it. But if you don't live nearby, you might not visit it often. And even if you do, you may have forgotten what a remarkable place it is.

For starters, it's a volcanic cone in the middle of a major city, and if that isn't unique, it has to be close. But let's review what's available in this amazing place: a not-complete list includes paved and unpaved forest paths, city and mountain views, picnic areas,

Everybody loves the views of Portland from the top of our local volcano.

tennis and basketball courts, volleyball areas, horseshoe pits, historic reservoirs, and an off-leash dog area. And yet the park is big enough to handle all of that while keeping it all more or less separate from each other, and it's pretty rare (aside from a sunny summer weekend day) to experience Mount Tabor as nutty or busy.

I like to park on one of the side streets off SE 60th Avenue and wander up into the woods, then make my way over to the reservoirs to check in with the Bigleaf Linden Heritage Tree (above the highest reservoir), and then climb the hill to the tree-lined oval at the summit. Up there you'll always find folks who've gotten their exercise coming up the steps, but such isn't my style. I am with the park-benchers, and my favorite sitting spot is the one with the exquisite view of Mount Hood, framed by tall evergreens.

Sitting on top of a volcano in the middle of my hometown, looking out past the tall trees, over the city, and out toward the mountains . . . yeah, Portland is pretty cool.

⌣ essentials

⌨	SE 60th Avenue at SE Salmon Street, Portland, OR 97215 **GPS coordinates:** N45° 30.698' W122° 35.713'
ⓒ	(503) 823-7529
⊕	tinyurl.com/mounttaborpark or taborfriends.com
$	Free
⊙	Daily, 5 a.m.–midnight; closed to motor vehicles Wednesday
⛐	**TriMet Bus:** #15 to SE 69th Avenue and Yamhill Street (north entrance) or #71 to SE 60th Avenue and Hawthorne Street (west entrance)

peaceful place 52

MULTNOMAH COUNTY CENTRAL LIBRARY
Downtown, Central Portland (MAP 1)
CATEGORY ↙ reading rooms ✪ ✪

*Y*ou'll hear many claims about Portland, some of them silly and maybe none of them true: most restaurants per capita, strip-joint capital of the country, biggest consumer of Pabst Blue Ribbon.

My favorite is that we check out more books from the library, per person, than any other city in America. Again, I don't know if it's true, but I know we have a beautiful main library, and we love it to pieces.

One of several grand, high-ceilinged halls at the Multnomah County Central Library

It's a temple to the book, complete with quotations from great literary masters inscribed on marble walls outside. Inside is a grand staircase, luxuriously carved and usually adorned with a massive flower arrangement. The ceilings are high and the feeling is majestic, and even with the crush of people around the Internet stations, there remains a sense of reverence and importance.

In 2013 the building turned 100 years old, and it was massively renovated from 2004 to 2007. In fact, when I moved to town in 1996, the library was housed where there's now a 24 Hour Fitness facility, and people were overjoyed about the restoration of the 10th Avenue site. I couldn't understand why, until I visited the old place and saw the artwork, the gallery spaces, the Sterling Room for Writers (admission by application only), and the Wilson Special Collections, packed with historic books and documents.

So it isn't just a library, yet it remains a vital part of the downtown community. You can get online there, browse maps and periodicals, spread out your papers and get some work done, or come by for a lecture or other event. Or you can simply grab a coffee at the Starbucks counter, find a quiet corner, and sit down with your volume of choice.

⌣ essentials

☰	801 SW 10th Avenue, Portland, OR 97205
✆	(503) 988-5123
✈	events.multcolib.org/venues/central-library
$	Free
☽	Sunday, 12–5 p.m.; Tuesday–Wednesday, 11 a.m.–8 p.m.; Thursday–Saturday, 10 a.m.–5 p.m.
🚋	**MAX Light Rail:** Red or Blue Line to Galleria/SW 10th Avenue or Library/SW Ninth Avenue **TriMet Bus:** #15 to SW 10th Avenue and Morrison Street or SW 10th Avenue and Salmon Street

peaceful place 53

NEWPORT BAY RESTAURANT

Riverplace, Central Portland (MAP 1: SEE 53A);
Lloyd Center District, Northeast Portland (MAP 3: SEE 53B);
Beaverton, Oregon (MAP 8; SEE 53C)

CATEGORY ⌣ quiet tables ⭐

*I*n the pantheon of Portland restaurants, Newport Bay is hardly a cutting-edge name. It's neither a fancy Pearl location nor a well-reviewed new foodie hangout nor a wait-all-day weekend-brunch hot spot. Its Riverplace location is, however, pretty much the only floating restaurant in town.

You're sitting there, literally on the Willamette River, with boats going by and a bridge overhead, ducks and geese hanging around, munching on your fish-and-chips or razor

At Newport Bay, you can almost imagine yourself dining on the deck of your own yacht.

clams or oysters or salmon, with the skyline one way, over past the boat basin, and Ross Island the other. Who needs cutting edge?

Immediately off the bar area, there's a row of tables along one side, a covered space with a grill on the other. Off the dining room is a little nook with a front-row view of the boats that will make you wish you were rich enough that Newport Bay would be cheap eats.

It isn't cheap for most of us, but a daily happy hour runs 3–6 p.m. and 9 p.m.–close. And there's the view. And the river. And sunsets. Mix in some fresh seafood with that, and you'll *feel* rich if nothing else.

essentials

This location (Riverplace): 0425 SW Montgomery Street, Portland, OR 97201
Lloyd Center: 1200 NE Broadway, Portland, OR 97232
Tanasbourne: 2965 NW Town Center Loop, Beaverton, OR 97006

This location (Riverplace): (503) 227-3474; Lloyd Center: (503) 493-0100; Tanasbourne: (503) 645-2526

newportbay.com

Lunch: $12–$18. Dinner: $15–$25. All-day menu: $5–$18.

Sunday–Thursday, 11 a.m.–9 p.m.; Friday–Saturday, 11 a.m.–10 p.m.

Portland Streetcar: SW River Parkway and Moody Avenue

peaceful place 54

NEW RENAISSANCE BOOKSHOP

Nob Hill, Northwest Portland (MAP 6)

CATEGORY ↙ shops & services ✪ ✪

\mathcal{T}here was a time when my Tennessee-raised self would have either laughed at or run from a place like New Renaissance. Upon first hearing words like *astrology, chakra, shamanic,* and *tarot,* I would have at least loaded up my sarcasm cannon and let fly.

New Renaissance is like a buffet for your spiritual hunger.

After 15 years in Portland, I've come around. In 2011, I spent a magical evening at the New Renaissance Event Center next door, listening to a shaman describe what he calls the Modern Mystical Movement—and realizing he was talking about me. And in Portland, the community of seekers, those who honor the wisdom and beauty in all spiritual and religious traditions, have a magical kind of hub over on NW 23rd Avenue.

To walk into New Renaissance is to be welcomed by countless images of serenity and beauty: photos, music, incense, books, CDs, and even a Zen alarm

clock promising a "gradual awakening" with chimes set to a "golden ratio" of ever-shorter intervals. (Trust me—it's awesome.) There's even a meditation room upstairs.

Listed first under "Spiritual Values" at the New Renaissance website is the statement "Spiritual growth is our business," and they mean it. It's a wonderful shop, filled with wisdom and paths to peace, hosting events that are all about healing and spiritual nourishment.

I'm glad I came around.

☙ essentials

▤ 1338 NW 23rd Avenue, Portland, OR 97210

☏ (503) 224-4929

🌐 newrenbooks.com

$ Free to browse; event fees free–$150

🕐 Monday–Thursday and Saturday, 10 a.m.–9 p.m.; Friday, 10 a.m.–9:30 p.m.; Sunday, 10 a.m.–6 p.m.

🚌 **Portland Streetcar:** NW 23rd Avenue and Marshall Street
TriMet Bus: #15 or #77 to NW 23rd Avenue and Overton Street

peaceful place 55

NORTHWEST LEIF ERIKSON DRIVE

Hillside, Northwest Portland (MAP 6: SEE 55A AND 55B)

CATEGORY ꞈ enchanting walks ✪ ✪

*T*here is a sweet irony about Forest Park and its great avenue, Leif Erikson Drive, beginning with the fact that you can't drive on it.

The city, you see, intended to devour this forest. In the early 20th century, a land

A jogger out on a morning run on Leif Erikson Drive in Northwest Portland

boom led to the construction of an 11-mile scenic drive (the trees had almost all been logged off, so there were plenty of views). But landslides meant that the road was often closed and the houses couldn't be built, and when the Depression hit, the city suddenly found itself the owner, via foreclosure, of some 3,000 acres.

In 1948, civic leaders resurrected an old plan: let's make this a forested park and then leave it alone. Today the park includes more than 5,000 reforested acres, about 70 miles of trails, and this 11-mile treasure of a road. The "road" is open only to hikers, bikers, and stroller pushers.

Leif Erikson offers few far-off views or dramatic rock formations, but it is replete with trees, small seasonal creeks, and a year-round array of songbirds, coyotes, squirrels, raccoons, owls, and hawks—more than 112 animal species in all. Leif Erikson Drive wanders nearly level through all of this, intersecting virtually all the park's trails, and even after the worst winter rain it doesn't become a mud bog as the hiker-only paths do.

The most popular place to access Leif Erikson for your walk is at the very end of NW Thurman Street, which turns into Leif Erikson at a gate. There is some parking here, but on weekends it's a zoo. I recommend starting at the far end, at a marked trailhead (also with parking) on NW Germantown Road, about 2 miles up from US 30. There, it's the same road and scenery but a lot more solitude.

essentials

📧 **Popular south access and parking:** End of NW Thurman Street, Portland, OR 97210
GPS coordinates: N45° 32.343' W122° 43.524'
More-tranquil north access and parking: NW Germantown Road, Portland, OR 97231
GPS coordinates: N45° 35.351' W122° 47.424'.

ⓒ **Forest Park Conservancy:** (503) 223-5449

🌐 forestparkconservancy.org or portlandhikersfieldguide.org/wiki/forest_park_trails

$ Free

🕐 Daily, 5 a.m.–10 p.m.

🚌 **TriMet Bus:** #15 to NW Thurman and Gordon Streets, about a 10-minute walk from the Thurman Street trailhead

peaceful place 56

NORTHWEST MARSHALL STREET

Nob Hill, Northwest Portland (MAP 6)

CATEGORY ↙ enchanting walks ✪ ✪

*T*he streetcar is a confined little world of lights and electronic sounds, filled with people listening to headphones or looking at a video screen in their hands. Stepping out, I sense the energy of the street, people rushing on and off, and up ahead I see the lights and cars on NW 23rd Avenue.

I take a few steps toward the madness, with shops and banks ahead of me and a hospital across the street, but even if I'm going that way, right off the streetcar I always veer right, onto NW Marshall Street and instantly into another world.

Marshall Street may be the perfect Northwest Portland thoroughfare.

Right away, it's quiet and woodsy. Looking up Marshall, I see houses flanking the street, tree-lined sidewalks, and the West Hills rising beyond. And what houses: massive piles with wraparound porches and gables and stained glass.

On the side where I walk, I relish the manicured lawns and admire the details of remodels: the doors, the light fixtures, the trim, the fountains. The word *stately* always comes to mind.

I don't know architecture, or the history of this block, nor do I care. I have several dreams for my life: wealth, love, eternal wandering, creative satisfaction—and the dream of living on the perfect little street in the right part of town, in a big, fancy, comfortable home. And by the time I've made it up to NW 24th Avenue, that dream is washing over me like a warm ocean wave.

Sometimes all I want is a house in the 2300 block of NW Marshall Street.

◡ essentials

⌨ 2300–2400 block of NW Marshall Street, Portland, OR 97210
GPS coordinates (NW 23rd Ave. and Marshall St.): N45° 31.830' W122° 41.928'

𝐶 n/a

🌐 n/a

$ Free

🕐 24/7; best in the early evening

🚃 **Portland Streetcar:** NW 23rd Avenue and Marshall Street

peaceful place 57

NORTHWEST SKYLINE BOULEVARD

West Hills, Northwest Portland (MAP 6: SEE 57A AND 57B)

CATEGORY ↲ urban surprises ✪ ✪

From my car, looking at the mess on US 26 in southwest Portland, I decide to take Skyline Boulevard over the hill in my journey north, for a little detour from the city.

Right away, the road gets windy and narrow and climbs the hill like a hiking trail. In a minute, I feel as though I'm in a national forest. I cross Burnside Road, put on some country music, and am startled by a view of Mount St. Helens, all the way up in Washington. Pulling over, I find myself in a tiny cemetery looking over tree-covered hills at a snowy volcano. *Where am I?*

There are homes all through the woods up here: mansions, hermit shacks, and dwellings that look like Japanese gardens. Arriving at Cornell Road, I see Skyline Restaurant,

At times on NW Skyline Boulevard, you'll think that you've left town and wound up in farm country.

in operation since the 1930s, and a fresh-fruit stand across the road. Technically, I'm in Northwest Portland. Culturally, I'm in the country.

I stay north on Skyline, heading back into the woods and passing a cut-your-own-noble-fir place. Next comes the shock of brand-new housing developments, and I wonder why they have to take out *all* the trees. Profit trumps conservation again. The timber stripping, however, gives me a view west, of the wide Tualatin Valley and the Coast Range beyond. We live in a lovely setting, no doubt.

I share the road with bikes and motorcycles and sporty convertibles, and also beat-up pickups. Passing Saltzman and Springville Roads, I know I'm in the vicinity of Forest Park trailheads. Past Newberry Road, I see the Skyline Grange hall and then come into real open country, with barns and horses. *This is Portland?*

I finally arrive at NW Cornelius Pass Road, which I know drops down to US 30, and I can take it south toward the St. Johns Bridge. Home is close from there. Skyline keeps going, though, and I am sorely tempted by a sign saying WINDING ROAD NEXT 8 MILES. But that will have to wait until next time.

⌣ essentials

▣	Bounded by West Burnside Road and NW Cornelius Pass Road, NW Skyline Boulevard, Portland, OR 97210, 97229, and 97231 The road travels a tortuous 18 miles along Portland's western flank. **GPS coordinates (NW Skyline Boulevard and West Burnside Road):** N45° 31.176' W122° 44.196'
ℭ	n/a
⦿	n/a
$	Free
⦿	24/7
🚘	n/a

peaceful place 58

OAK ISLAND

Sauvie Island, Outer Northwest Portland (MAP 7)

CATEGORY ↙ outdoor habitats ✪ ✪ ✪

*M*aybe you have fond memories of visiting Grandma in the country. Maybe you really like birds. Maybe you're looking for a safe, open place where the kids and dogs can romp. And maybe, while you're out there, picking some berries might be fun.

If this sounds like you, check out Oak Island, which is actually a peninsula in a lake on an island in a river. The latter island would be Sauvie Island, an oasis of country living and wildlife in the Columbia River west of Portland. And Oak Island is at the

A walk at Oak Island delivers country lanes, flowers, birds, and, well, oaks.

intersection of those two missions: a place where crops are grown to feed wildlife.

At the peak of the fall migration, some 150,000 ducks and geese lay over at Sauvie Island, as do several thousand sandhill cranes. Some 250 species of birds come here at some point, including many bald eagles in the winter.

The trail is closed during peak migration, but no matter when you come, you'll encounter songbirds, ducks, geese, and even some resident eagles. It's a flat 2.5-mile loop through the countryside, winding amid grassy meadows and patches of forest. You'll get a view of Sturgeon Lake and another of The Narrows, a strip of water that connects Sturgeon and Steelan Lakes.

You'll even see fields planted with alfalfa, corn, millet, and other foods for cows in the summer and migratory birds in winter. The state has a map with interpretive information (see second website in "essentials"). And Sauvie Island is dotted with pick-your-own-berries places for before or after your walk.

See what I mean? Crops, lakes, meadows, trees, berries, and birds. Just a nice little stroll in the country.

⌣ essentials

▣	End of NW Oak Island Road, off NW Reeder Road, Sauvie Island, Portland, OR 97231 **GPS coordinates:** N45° 42.876' W122° 49.234'
ℂ	(503) 621-3488
🌐	sauvieisland.org/visitor-information/natural-attractions/oak-island or tinyurl.com/oakislandtrailmap
$	Parking, $7/day or $22/year. Passes available at Cracker Barrel Grocery, 15005 NW Sauvie Island Road, Portland, OR 97231; Reeder Beach RV Country Store, 26048 NW Reeder Road, Portland, OR 97231; and Oregon Department of Fish and Wildlife, 18330 NW Sauvie Island Road, Portland, OR 97231.
🕐	**April 15–September 30:** Daily, sunrise–sunset
🚍	n/a

peaceful place 59

OAKS BOTTOM WILDLIFE REFUGE
Sellwood, Southeast Portland (MAP 4)
CATEGORY ↵ outdoor habitats ✪ ✪

*S*uch a dance there is between city and nature.

First, we cut off part of the river to build a railroad, so it becomes a seasonal wetland, still teeming with birds. Then we build, and tear up, a highway along the bank and dump all the debris next to the pond; it becomes a grassy meadow, which we replant with native species. Then English ivy, which we introduced elsewhere, invades, so we remove that and put in cedars and maples.

In winter, this part of the Oaks Bottom Trail might lie along a lakeshore.

And meanwhile, the area where all this happens is home to beavers, deer, raccoons, and 140 species of birds throughout the year: herons, ducks, cormorants, woodpeckers, ospreys, kingfishers, and bald eagles. And it's in the middle of the city, next to an amusement park.

This is Oaks Bottom, one of Portland's natural treasures, and at any time of year it's a respite from whatever is going on around it. Cross the railroad tracks and wander the woods along the bank. Follow the path around the wetlands and look for birds. Take the paved former railroad line along the lake. Check to see how the reintroduced native trees are doing.

The bird visits peak in spring and late fall; water is highest in winter; Oaks Amusement Park is a blast in summer. Whenever you go, the residents of Oaks Bottom are there, waiting to continue the dance.

essentials

SE Milwaukie Avenue and Mitchell Street, Portland, OR 97202
GPS coordinates: N45° 28.597' W122° 39.321'

Portland Parks & Recreation: (503) 823-7529
Friends of Oaks Bottom: (503) 823-6131

tinyurl.com/oaksbottom

$ Free

Daily, 5 a.m.–midnight; **North parking lot:** Daily, 5 a.m.–10 p.m.

TriMet Bus: #19 to SE Milwaukie Avenue and Mitchell Street or #70 to SE 17th Avenue and Mitchell Street, 1 mile away

peaceful place 60

OSWALD WEST STATE PARK
Arch Cape, Oregon (MAP 8)
CATEGORY ↙ outdoor habitats ✪ ✪

*I*n a few steps, you go from highway shoulder to ancient forest. You leave the world of cars and trucks and enter the world of trees, ferns, and creeks. Walk a little farther and you catch sight of the ocean, and soon you're scrambling down a trail to the white, sandy beach.

It sounds a little like a paradise, doesn't it? Well, that's the feeling you may get when you visit Oswald West State Park, especially if you can get there on a less-crowded weekday. Whichever option you choose—walking the trail to Cape Falcon, climbing Neahkahnie Mountain, or playing around on Short Sand Beach—you're getting a glimpse of something that almost got wiped out: our original coastal forest.

The least-crowded approach is along the trail to Cape Falcon, which is 2.3 miles long and virtually flat. After 0.5 mile or so, a side trail leads down to the beach and some of the biggest spruce trees you'll ever see. Smuggler Cove, as that spot is called, is largely protected from the biggest ocean waves and is a great place to surf or play in the (cold) water.

I like going on out to Cape Falcon, though. Over the next couple of miles you'll cross little creeks, see a waterfall, and even visit an old stump that looks like a throne, and then wind up at an (unfenced) viewpoint 200 feet above the sea. You can even go another mile or so for more ocean views along the Oregon Coast Trail.

Another nice trail heads south from the beach, to a viewpoint of Devils Cauldron. Grab a trail guide from the park or online. Then, at the end of the day, think about going up Neahkahnie (1.3 miles up from the south trailhead) for an amazing sunset.

Wherever you go, be sure to say thanks to the folks who helped save at least a little of what was.

essentials

Oswald West State Park, US 101, Arch Cape, OR 97102 (10 miles south of Cannon Beach)
GPS coordinates: N45° 46.516' W123° 56.733'

(800) 551-6949, (503) 368-3575, or (503) 368-5943

oregonstateparks.org/park_195.php

$ Free

Daily, sunrise–sunset

n/a

peaceful place 61

OUR LADY OF GUADALUPE TRAPPIST ABBEY

Lafayette, Oregon (MAP 8)

CATEGORY ∿ spiritual enclaves ✪ ✪ ✪

*A*nother morning on retreat. I never sleep so well in town. Maybe it's this simple little room, with just a bed, a chair, a desk, and a rocker. Perhaps it's the birdcalls outside, the breeze in the trees, and the compete lack of electronics. Whatever it is, my mind, body, and spirit are more peaceful every day. My only tasks here are self-care and reflection.

Maybe I'll go to the 6:30 morning Mass to hear those lovely monks singing their prayers. Then off to another healthy breakfast, eaten in silence. Then perhaps a walk in

The quintessence of peacefulness: sitting quietly by a waterfall at the Trappist Abbey

the forest, reading by the pond, or my own prayers and meditations on a cushion in the hall. Or a nap. Then another service, if I want, and lunch in silence, and then more of the same this afternoon.

"Come aside by yourselves to a deserted place and rest a while."

So says Mark 6:31, and the advice is still good some 2,000 years later. But the nice thing about a retreat at the abbey is that it's just the right amount of "deserted." It's a Catholic place, and a church for the little community around, but everyone is welcome. You can even meet with a monk if you'd like to talk. There are numerous lovely services throughout the day, but you're left to your own experience. Come for the day, spend a night, or spend a week. A month with the monks is even an option. It's really up to you.

How often does life in town give us this kind of opportunity?

essentials

📧 9200 NE Abbey Road, Lafayette, OR 97127

☎ (503) 852-0107

🌐 trappistabbey.org

$ **Suggested donation:** $50 per night; $20 for day use

🕐 **Office:** Monday–Friday, 9 a.m.–2 p.m.; reservations are taken up to four months in advance.

🚌 n/a

peaceful place 62

PIED COW COFFEEHOUSE
Sunnyside, Southeast Portland (MAP 4)
CATEGORY ↵ quiet tables ⭐

he lingering image after having a cup or plate at the Pied Cow could, depending on the season, be of an opium den, a Casbah, or a picnic on some hippie's farm.

Inside, the room seems always dark, as if to be a retreat from light itself. Servers come and go from a tiny kitchen, and the looming space of the big old Victorian house adds a sense of mystery; not only does it feel somehow hidden from Belmont Street, but one is also left to wonder what's upstairs.

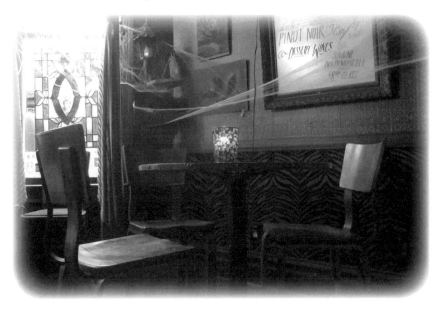

At the Pied Cow it always seems like nighttime, but it's far from gloomy.

The real draw of the place is the garden space outside, which in the summer is lit with holiday lights and other orbs hanging in the trees. People sit on uneven ground on mismatched chairs, on park benches under umbrellas, or in little coves next to or under shrubs and trees. It's very charming.

And Pied Cow serves hookahs. It's somewhat startling at first, if you're not from Portland and you see people with a big pipe between them, passing around a hose. Relax—it's just tobacco, but it does come in more than 15 flavors, including jasmine, margarita, mint, orange, and rose.

The rest of the menu might leave you feeling a little intoxicated. There are plenty of snack plates and yummy drinks, but the action is in desserts, where you can get items such as warm gingerbread cake, marionberry pie, chocolate velvet cheesecake, and a hazelnut-Nutella-banana crepe, which is served flaming with rum.

Somehow, "flaming with rum" seems about right for a dark, off-the-street place that invites you in for a soft-lit cup, a plate, and perhaps a smoke while making you wonder all the while where exactly you are.

essentials

3244 SE Belmont Street, Portland, OR 97214

(503) 230-4866

tinyurl.com/piedcowcoffeehouse

Plates: $5–$10. Drinks: $3–$5.

Monday–Thursday, 4 p.m.–midnight; Friday, 4 p.m.–1 a.m.; Saturday, noon–1 a.m.; Sunday, noon–midnight

TriMet Bus: #15 to SE Belmont Street and 32nd Avenue

peaceful place 63

PITTOCK MANSION

West Hills, Northwest Portland (MAP 6)

CATEGORY ↵ historic sites ★ ★

*I*magine being the king. Let's say that you had more wealth and power than anybody else, and you more or less ran the town. Furthermore, imagine that you'd come from being barefoot and penniless to your role as a successful businessman and community leader. You just might want to build a big old house on the hill and look out over your domain, wouldn't you? And you'd fill it with stuff such as a Steinway piano, Tiffany artwork, and so on.

That's pretty much what Henry J. Pittock did: he came to Oregon in an 1853 wagon train and by 1860 owned the *Oregonian* newspaper. Fifty years later, he and

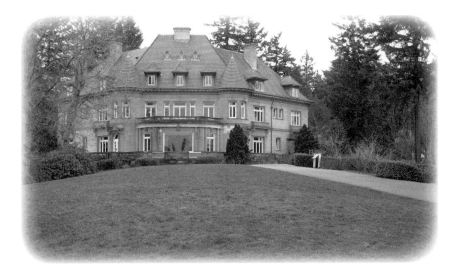

The Pittock Mansion boasts Portland's grandest front yard.

his wife built this massive estate, and in the 1960s the city bought it to preserve it and make it a landmark.

But even if you don't want to tour the house, you can wander the 54-acre park it inhabits, or have a picnic in the front lawn, at a table with the city view. A great way to see it is by hiking to it; the Wildwood Trail of Forest Park passes right by it, and if you start at Macleay Park (see page 93) and hike up past the Audubon Society (see page 5), you can continue on the Wildwood to the Pittock Mansion. It's 2.3 miles one-way from Macleay Park to the mansion.

Even if you're not a hiker or not too interested in the mansion, there's no finer view of Portland, no sweeter spot to watch the sun go up or down, and no better way to see the world as a king might.

↶ essentials

⌑ 3229 NW Pittock Drive, Portland, OR 97210

✆ (503) 823-3623

🌐 pittockmansion.org

$ **Mansion tour:** $5.50–$8.50; **Grounds:** Free

🕐 **February 1–June 30:** Daily, 11 a.m.–4 p.m. **July 1–August 31:** Daily, 10 a.m.–5 p.m. **September 1–December 31:** Daily, 11 a.m.–4 p.m. Closed in January.

🚌 **TriMet Bus:** #20 to West Burnside and NW Barnes Roads

peaceful place 64

PORTLAND INTERNATIONAL AIRPORT (PDX)

Columbia Corridor, Northeast Portland (MAP 3)

CATEGORY ⌣ urban surprises ⊛ ⊛

F or so many people, an airport is a stressful place. They're worried about catching their planes, or the security checks stress them out, or they're corralling kids.

Myself, I love airports, because I love traveling and I love being around fellow travelers. I am fascinated by the notion that everybody walking the halls at PDX will, within hours, be literally all over the country. I also love the big, efficient system that is a modern airport: part mall, part transit hub, part governmental bureaucracy, and part museum.

A quiet little nook at the airport, where it's always time to travel

A while back, a friend told me that there was a peaceful place at the airport: upstairs, above the piano player. The next time I was flying somewhere, I went even earlier than usual—I always get there early, to make sure all is well but also to relax into my groove— and I sought out the piano player.

Gotta love Portland: we have multiple musicians and singers all over the airport. To find this particular musician, and this particular spot, you need to go to the shopping area. Once there, look for a staircase that leads to some offices and meeting rooms.

It's nothing spectacular, but it's a little behind-the-scenes view of things, and at the top of the steps is a little, um, place. I'm not sure what else to call it. A landing, let's say. And it has a view from above of the hallway, filled with travelers and workers. You'll be level with the clocks showing the time in different cities. And if you hang out there for a minute, before you fly off somewhere, perhaps you can catch a little of that humming, multidimensional airport vibe that I love so much.

Or maybe you can just clear your head a bit before your trip.

⌣ essentials

⌐≡ 7000 NE Airport Way, Portland, OR 97218

☏ (503) 460-4040

🌐 flypdx.com

$ Free, unless you park there ($3/hour) or fly someplace

🕐 24/7

🚆 **MAX Light Rail:** Red Line to PDX

peaceful place 65

PORTLAND JAPANESE GARDEN

West Hills, Southwest Portland (MAP 5)

CATEGORY ⌣ parks & gardens ✪ ✪ ✪

By the time you've walked the winding gravel path and passed through the ornate wooden entrance gate, you'll know that you've arrived somewhere. This is the essence of a Japanese garden: a sense of peace and tranquility, and a connection to nature.

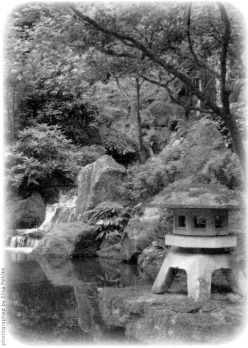

photographed by Elisa Pehlke

A waterfall slips into Strolling Pond at the Portland Japanese Garden.

A Japanese garden is not about flowers, and certainly not about neat rows or paths. It's about stone as the bones of a garden, water as its life-giving force, and plants to provide the colors of the four seasons. It's about the calming experience of being in nature yet also in the hands of a master gardener.

Portland's Japanese garden is considered one of the best and most authentic outside Japan. Even calling it a garden short-changes it, as it actually comprises five distinct sections: the Strolling Pond Garden, with its luscious plant and water features; the Flat Garden, its

raked-gravel landscape meant to resemble a sea; a Tea Garden of soothing architecture and intricate formality; the Natural Garden, where uneven paths meander along a hillside; and finally the stark, beautiful simplicity of the Zen Garden.

To walk here is not to follow a plan—although a guided tour makes a fine introduction—but rather to follow your impulses, gaze at the scale or the details, and perhaps let yourself walk in silence.

In fact, even walking can miss the point. Find a place where you feel a connection, and simply sit. Let the garden tell you what it wants to say . . . which might be nothing at all.

⌣ essentials

611 SW Kingston Avenue, Portland, OR 97205

(503) 223-1321

japanesegarden.com

$ Adults, $9.50; seniors age 62 and older and students with ID, $7.75; children ages 6–17, $6.75; children age 5 and younger, free

October 1–March 31: Monday, noon–4 p.m.; Tuesday–Sunday, 10 a.m.–4 p.m.
April 1–September 30: Monday, noon–7 p.m.; Tuesday–Sunday, 10 a.m.–7 p.m.

TriMet Bus: #63 to SW Kingston Avenue and Japanese Garden (only Monday–Friday)
Max Light Rail: Blue or Red Line to Washington Park, and then (daily, Memorial Day–Labor Day or Saturday–Sunday, May, September, and October) take TriMet #83 to the garden

peaceful place 66

PORTLAND WOMEN'S FORUM STATE SCENIC VIEWPOINT

Corbett, Oregon (MAP 8)

CATEGORY ⌣ scenic vistas ✪ ✪

*Y*ou already know the vista: the mighty Columbia River winding through a deep gorge, a palette of blue water, green trees, and gray rocks that together count among the truly awesome views in America. You know it because you've seen it yourself, or at least you have in a million calendars and books.

Did you know that you can enjoy the same vantage point, maybe even better, without going near the out-of-control crowds at the Vista House?

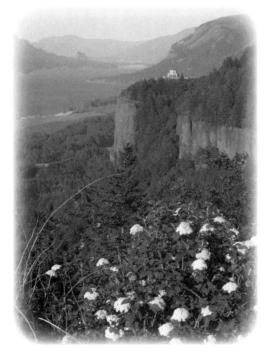

The view from the Portland Women's Forum State Scenic Viewpoint is at least as good as, and certainly quieter than, the one from Vista House.

Looking at the Columbia Gorge from the Portland Women's Forum State Scenic Viewpoint—a panorama which, by the way, includes the Vista House—is like sitting off to the side at a rock concert or going to an art gallery right at opening time. It's the same view with no hassles. In fact, I think it offers a

better spot than Vista House does; throw in the solitude, and it's a pure winner.

There's really not much else to say, except for a little history. The piece of land is called Chanticleer Point, and 100 years ago an inn was located here. A road came up from a train depot at Rooster Rock, and the upper parts of that road are still here; you can walk a bit of it from the western side of the parking lot.

As for the other name, the Portland Women's Forum bought the place after the inn burned and donated it to Oregon State Parks. Good for them—and good for you, for getting a great view without the crowds.

⌣ essentials

From Portland, drive east on I-84 for 19 miles. Take Exit 22/Corbett and turn right onto NE Corbett Hill Road. After 1.5 miles, turn left onto East Historic Columbia River Highway and drive an additional 1.5 miles to the viewpoint, on your left.
GPS coordinates: N45° 32.004' W122° 15.654'

(800) 551-6949

oregonstateparks.org/park_164.php

$ Free

24/7

n/a

peaceful place 67

POWELL BUTTE NATURE PARK
Midway, Southeast Portland (MAP 4)
CATEGORY ↙ parks & gardens ✪ ✪

*Y*ou wouldn't know it today, but there's been a lot going on at Powell Butte for a long time.

First it was a volcano, thankfully now extinct. Then it was a farm and orchard for decades. Then the city bought it to build underground water reservoirs. Only one of those was built, but it's the place where water from Mount Hood arrives in the city. And because of the butte's elevation, everybody on the east side of town gets their water from here entirely via gravity.

A woodsy country stroll in the heart of southeast Portland? Yep, at Powell Butte.

There was also a dairy here until 1948, and cows until the 1970s, and finally this city park in 1987. But it still feels a lot like it's in a natural state. In fact, if you drive just south of it, across Foster Road, you'll be in Pleasant Valley among farms and winding creeks, but still well within metro Portland.

Up on the butte, 9 miles of trails wind up and down, in and out of 611 acres of woods and meadows. The highlight for most is the summit, at 614 feet, with a mountain finder pointing out the five Cascade volcanoes you can see on a clear day. But it's also pleasant to wander through the forests, looking for rock formations and springs and maybe even a fox or coyote, or to hop onto the Springwater Corridor Trail, which runs along the boundary of the park.

So yeah, there's still a lot going on at Powell Butte: a lot of what makes Portland so cool.

⌣ essentials

▭ 16160 SE Powell Boulevard, Portland, OR 97236

☎ (503) 823-7529

⊕ tinyurl.com/powellbutte or friendsofpowellbutte.org

$ Free

🕓 Daily, 5 a.m.–10 p.m. **Parking lot: Spring (until Memorial Day) and Labor Day–Pacific Standard Time:** Daily, 7 a.m.–8 p.m. **Memorial Day–Labor Day:** Daily, 7 a.m.–10 p.m. **Winter (until switch to Daylight Saving Time):** Daily, 7 a.m.– 6 p.m. All trails are closed when muddy. Check the website for details.

🚌 **TriMet Bus:** #9 to SE Powell Boulevard and 160th Avenue

peaceful place 68

POWELL'S CITY OF BOOKS: THE RARE BOOK ROOM
Pearl District, Central Portland (MAP 1)
CATEGORY ↻ reading rooms ⬤ ⬤ ⬤

*I*f every culture has its spiritual heart, then Powell's City of Books is Portland's tabernacle. And the Rare Book Room may be its holy of holies.

We are a book-loving town, and Powell's is one of our most cherished possessions— a staggering collection of titles that sprawls several levels over a city block, with satellite stores around town.

Near the top of the original store location, behind a closed door, often behind glass cases, sit the treasures. It could be a first edition of W. B. Yeats's *The Tower* from 1928,

The Rare Book Room: the sanctum sanctorum of Powell's City of Books

a signed copy of *Fight Club* by Portland's own Chuck Palahniuk, a 1957 first edition of Andy Warhol's *Holy Cats by Andy Warhol's Mother,* or a signed copy of Douglas Adams's *Life, the Universe, and Everything.*

They might be particularly old books, such as an 1836 *Life of George Washington,* a 1905 *Mother Goose,* or even an original 1775 copy of the New England Restraining Act. They could be big novelty books, such as an enormous picture book of DC Comics, or Carl Jung's *Red Book.* Or it could be something truly rare, such as a copy of Nathaniel Hawthorne's *House of Seven Gables,* hand-bound by Virginia Woolf. (That one, by the way, will set you back $9,500.)

Yes, all these books are for sale. But for most of us, they are more to be contemplated and admired. And the Rare Book Room is a calm, serene place in the middle of a literal city of books. So go there and let a literary calm and awe settle over you, feel the impact of all the years, take a break from simple browsing and shopping, and be grateful that such a place as Powell's is still with us.

↙ essentials

⊡ 1005 West Burnside Street, Portland, OR 97209

𝒞 (503) 228-4651; **Rare Book Room:** (800) 878-7323, ext. 1270

🌐 powells.com/rareandcollectible.html

$ Free to browse; **Rare books:** $23–$14,000 and up

🕐 Daily, 9 a.m.–11 p.m.
 Rare Book Room: Saturday–Sunday, 11 a.m.–7 p.m. or by appointment

🚈 **Portland Streetcar:** SW Stark Street and 10th Avenue
 TriMet Bus: #20 to West Burnside Street and SW 10th Avenue

peaceful place 69

PRASAD

Pearl District, Central Portland (MAP 1)

CATEGORY ↝ quiet tables ✪ ✪

wonder if there is a higher concentration of healthy, happy people at Prasad, the little café in the lobby of Yoga Pearl, than there is elsewhere in Portland. I am certain that Prasad is the only dining establishment in town with little signs on the tables that read SHHH.

And the signs aren't meant in a negative way, as in "shut the heck up." The signs mean that there are people doing yoga and meditation nearby, and besides, the world is loud

Prasad radiates peace, quiet, and health.

enough, so in here let's all keep it down a little, relax, and eat some überhealthy food.

You enter by the fountain, step to the counter, and order from a menu bursting with color, taste, and cheer. Consider the Bliss Salad: dried currants, Calimyrna figs, walnuts, quinoa, beets, carrots, and mixed greens with lemon-ginger dressing. Or the Dragon Bowl: Bhutanese red rice or quinoa; beans; arame, wakame, and dulse (types of seaweed); avocado; steamed greens; sesame seeds; scallions; and red cabbage.

The café serves breakfast; drinks such as the Wellness Toddy (fresh lemon, ginger, local honey, cayenne, and echinacea in hot water); bowls; soups; greens; juices; and Health Elixirs such as Harvest Cider (apple, lemon, and ginger juice, steamed with cinnamon and cayenne).

It's all organic, and the word *love* appears about 37 times on the menu and website. It's all enough to quiet you so you can savor the moment and the meal.

∴ essentials

⌐≡' 925 NW Davis Street, Portland, OR 97209

℃ (503) 224-3993

🌎 prasadcuisine.squarespace.com

$ **Entrées:** $6–$9

🕓 Monday–Friday, 7:30 a.m.–8 p.m.; Saturday–Sunday, 9 a.m.–8 p.m.

🚌 **Portland Streetcar:** NW Everett Street and 10th or 11th Avenue
TriMet Bus: #17 to NW Everett or Glisan Streets and Park Avenue

peaceful place 70

REED COLLEGE

Woodstock, Southeast Portland (MAP 4)

CATEGORY ⌣ enchanting walks ⭐

 *R*eed isn't just a place where brainy rich kids hang out for four years. Although I do wish to point out that tuition, room, and board add up to about $54,000 per year, and the school claims that only three universities in America see a higher percentage of its graduates get PhDs. (And let's not forget that Steve Jobs attended Reed, though he wasn't what you'd call a dedicated student for the required courses and he didn't graduate.)

Bridge over Reed Canyon

But let's talk about the canyon and the trees. A few dozen species grow on campus, from Alaska cedar to Japanese zelkova. Many of them ring the grand South Lawn, and five of them are Portland Heritage Trees, including a Port Orford cedar and two ginkgos taller than 40 feet. I'll leave it to you to find them because I want you to wander the various courtyards and clearings all over the campus. It's a stroller's paradise.

And then there's the canyon, which you'd never know about if you didn't get out of your car and look around. Yes, Reed has a 28-acre watershed running east–west through the campus, complete with springs and bridges and critters; a blog tracks the comings and goings of otters, beavers, geese, and ducks. That blog (see "essentials," below) says that if you want to see beavers, hang out by the amphitheater on the south side of the canyon right around dusk; the dens are along that bank.

Obviously, it matters when you visit the campus. When students are around, it won't be all that quiet, and early in the morning or at night you might attract unwanted attention. So check the school calendar for times such as spring or winter break, or come over right after graduation in mid-May, when the bushes are blooming, the birds are in full song, and all the leaders of tomorrow are on vacation.

⌣ essentials

⊟ 3203 SE Woodstock Boulevard, Portland, OR 97202

ⓒ (503) 771-1112

⊕ reed.edu or blogs.reed.edu/reed_canyon

$ Free

🕐 Daily, sunrise–sunset

🚌 **TriMet Bus:** #19 to SE Woodstock Boulevard and 32nd Avenue

peaceful place 71

ROCKY BUTTE NATURAL AREA
Roseway, Northeast Portland (MAP 3)
CATEGORY ↙ scenic vistas ✪ ✪

*W*henever I give folks my one-day tour of Portland, we always wind up at Rocky Butte. Whether we've been up to Timberline Lodge, wandering the Columbia River Gorge, or walking the city's neighborhoods, I always want to close the day with the view from the little park on top of the butte. It's the best overall view of where we live—which, after all, is in a big city where two big rivers come together, seemingly at the foot of a big volcano.

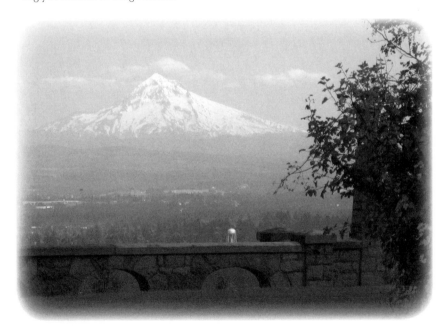

Mount Hood in all its glory from the top of Rocky Butte

Officially, I can tell my guests that Rocky Butte is an extinct volcanic cinder cone and that it used to be home to a jail, a quarry, and a Baptist college. All of that is long gone. In its place we have a quiet, grassy little park, surrounded by rock walls, littered with climbing routes, and topped off by a cell phone tower that you'll hardly notice.

That's because Rocky Butte has amazing views: west to downtown, east to Mount Hood and the Columbia Gorge, and north to the airport. I love sitting up there in the evenings, watching planes come and go while the city's lights start to twinkle and the setting sun paints Mount Hood in pink alpenglow. All at once, I'm reminded that Portland is an international city but also a small town; bustling but with pockets of nature and serenity; by the river but surrounded by mountains; and at the end of the day, just darn lovely.

❧ essentials

🖃 NE Rocky Butte Road, Portland, OR 97220
 GPS coordinates: N45° 32.763' W122° 34.041'

📞 (503) 823-7529

🌐 tinyurl.com/rockybutte

$ Free

🕐 Daily, sunrise–sunset

🚌 **TriMet Bus:** #24 to NE 92nd Avenue and Russell Street, 0.5 mile down the road

peaceful place 72

SALMON RIVER TRAILS

Zigzag, Oregon (MAP 8)

CATEGORY ↙ day trips & overnights ✪ ✪

*L*et's get right to the point: here are two easy trails through an ancient forest along a mountain stream with salmon in a wilderness area. There's even a campground if you want to spend the night.

The Salmon River flows off Mount Hood and is the only river in the lower 48 states to be classified as Wild and Scenic from its headwaters to its mouth. Where these trails follow it, the river emerges from a steep, narrow canyon that remains virtually inaccessible. Along this section, however, the river is constantly within range of eyes and ears, and numerous side paths lead down to its bank.

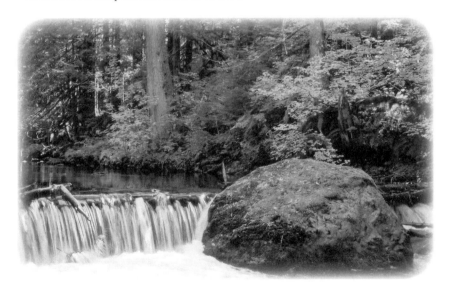

Waterfall along the Salmon River Trail, upstream from the bridge

You may, however, find it hard to focus on the river. That's because the forest here is amazing. Douglas-firs tower hundreds of feet, western red cedars measure a dozen feet thick, moss drapes over everything, and wildflowers carpet the ground.

And yes, you may see spawning salmon, with the run peaking from late September into October. (Their arrival coincides with the fall colors.) Sometimes they get within feet of the bank, in water so shallow that their frenetically swimming bodies surface.

Though there are technically two trails, it's really just one path along the river, and several trailheads give you choices along the way. Turn up Salmon River Road from Zigzag on US 26, and you'll see trailheads along the road offering access to the Old Salmon River Trail. Then, when the road crosses the river again, you'll see parking for the Salmon River Trail, which continues upstream from here. The lower trail is 2.2 easy miles, and the upper sticks to the river for a couple of miles, passing several nice campsites, and then climbs a little more than a mile to a canyon viewpoint.

All of this can get a little busy on summer weekends. At other times, it may be only you and the fish.

�™ essentials

📄 From Portland, drive 36 miles east on US 26. Turn right on Salmon River Road and continue 2.7 miles to reach the lower trailhead (immediately beyond the MOUNT HOOD NATIONAL FOREST sign), or drive 4.9 miles to the upper trailhead, at a bridge over the river. **GPS coordinates: N45° 18.646' W121° 56.615'**

📞 **Zigzag Ranger District:** (503) 622-3191

🌐 **Old Salmon River Trail info:** portlandhikersfieldguide.org/wiki/old_salmon_river_hike

$ A Northwest Forest Pass is required for admission ($5/day, $30/year); buy online at tinyurl.com/region6passes.

🕐 24/7, but not recommended after dark. The trails are open year-round but are often snow-covered in winter. Call the ranger office for conditions before you go.

🚌 n/a

peaceful place 73

SALT GROTTO
Pearl District, Central Portland (MAP 1)
CATEGORY ⌣ shops & services ✪ ✪ ✪

*T*hink about the salty air you love to breathe down at the beach. You know how you feel refreshed afterward—cleared out, a little more alive? Now think about that experience condensed into a pure form, the equivalent of apple juice compared with a bite of apple.

That's what happens to your senses when you walk into the artificial salt cave known as the Salt Grotto. The location seems incongruous, surrounded by a sports bar, office supply place, and an REI. Inside it looks like a pretty standard gift shop, except for the salt lamps and Czech mineral water. But wait.

In the cave, the walls are made of salt from Poland and Pakistan. A layer of Dead Sea salt covers the floor. A salt waterfall mesmerizes. A line of recliners parallels one wall, and the corner hosts a kids' play area. A temperature of 75° prevails inside, and when the door shuts, you are to be quiet.

And then what? Well, whatever you want. Some folks sleep, some meditate, and some read. No phones, food, or drink are allowed.

The whole point of this is the therapeutic effects of breathing salty air. I won't try to explain that phenomenon—see the website for more on that—but it does somehow feel right. And if just sitting isn't your thing, Salt Grotto also offers yoga classes, massages, and meditation sessions.

Otherwise, you have 45 minutes per session to chill out and breathe in the healthy, salty air.

⌣ essentials

906 NW 14th Avenue, Portland, OR 97209

(971) 255-1053

thesaltgrotto.com

Grotto rental: $30 per 45-minute session; **Classes and spa services:** $30–$130

Tuesday–Saturday, 10 a.m.–7 p.m.; Sunday–Monday, noon–7 p.m.

Portland Streetcar: NW 13th Avenue and Lovejoy Street
TriMet Bus: #77 to NW 13th Avenue and Lovejoy Street

peaceful place 74

SANDY COVE INN

Seaside, Oregon (MAP 8)

CATEGORY ↝ day trips & overnights ✪ ✪

*I*f you know anything about Oregon, you probably don't associate Seaside with *serenity*. Most famous for its main drag of arcades and toffee shops and its super-crowded beach, Seaside is the touristy counterpoint to mellow Cannon Beach.

But I've found the quiet corner of Seaside and gotten to know its simpler charms. And when I go, I stay at the Sandy Cove Inn.

The Sandy Cove Inn is far from Seaside's madding crowd.

It's on the less hectic end of town, two blocks from the beach and promenade but a mile away from the madness by the turnaround. A market is right across the street if you want to do your own cooking. And the owners, Betsy and Mike, have two sweet little girls, so they can show you charming, kid-friendly stuff, such as the local painted-rock garden where you're encouraged to contribute your work. They are also, for the history buffs, a few blocks from the site of the Lewis and Clark Salt Works, where the members of the Corps of Discovery spent two months in 1805 making salt. (This event is even reenacted every third weekend of August, very near the inn.)

The rooms at Sandy Cove range from whimsical (the Vintage Game Room or the Wave Room) to retro (the 1940s and 1960s rooms) to indulgent (the Jacuzzi and Columbia Tower suites). Outside those rooms you'll find plenty of things to do. How about a hike to the top of Tillamook Head? A paddle around the waterways? A bike ride or birding expedition?

In Seaside, it's not all about the bumper cars and candy shops. Let Betsy and Mike put you up and show you its cooler, calmer side.

☙ essentials

✉	241 Avenue U, Seaside, OR 97138
©	(503) 738-7473
🌐	sandycoveinn.net
$	**Rates:** $75–$190
🕐	24/7
🚌	n/a

peaceful place 75

SERENITY SHOP

Division/Clinton, Southeast Portland (MAP 4)

CATEGORY ⸖ shops & services ✪ ✪ ✪

*Y*ou might not realize it, but there's a good chance that you know somebody in recovery. Alcoholics Anonymous alone figures that it has more than 1.25 million members in the United States.

The backyard of the Serenity Shop is a secret oasis of calm.

AA has played a major role in modern America's embrace of spiritual solutions to life's problems, and the 12-step world has become quite literally a subculture all its own. In Portland, the Serenity Shop is one of its gathering places.

You don't have to be a friend of Bill W. to enjoy the shop, though. Sure, there's a whole shelf of sobriety coins, and a case of 12-step workbooks, but you'll also find jewelry, medallions, and stickers with various spiritual or self-help slogans. The shop's wide range of books and CDs range from Native American wisdom to relationship advice to every form of

religion you can imagine. To me, it's nice to walk around and be surrounded by slogans such as "Keep It Simple," "One Day at a Time," and "Expect Miracles."

But here's an extra little surprise I found after introducing myself to the staff. If you go through the kitchen to the backyard, you'll find a quiet, secluded little garden. There's a tiny pond, some statues, and covered-area seating for several people. (*Note:* Be aware that the occasional 12-step meeting takes place back there, or in the kitchen when the weather is bad.)

I think of the world of recovery as being a series of campfires all over the world, offering comfort, warmth, and guidance to the addict who's still suffering. And the Serenity Shop is a mighty warm place to hang out.

⌣ essentials

	3212 SE Division Street, Portland, OR 97202
☏	(503) 235-3383
🌐	serenityshop.com
$	**Books and CDs:** up to $15. **Medallions and stickers:** around $2.
🕐	Monday–Friday, 10 a.m.–6 p.m.; Saturday–Sunday, noon–5 p.m.
🚌	**TriMet Bus:** #4 to SE Division Street and 32nd Avenue

peaceful place 76

SILVER FALLS STATE PARK

Sublimity, Oregon (MAP 8)

CATEGORY ↵ day trips & overnights ✪ ✪

*J*f you're a local, you may chuckle at the idea of Silver Falls State Park being tranquil. This day-trip destination, only a 90-minute drive from the heart of downtown Portland, is beautiful, enchanting, and the jewel of the state-park system, sure. But unless you know *when* to go, it's not necessarily peaceful, what with the sprawling campsite, hordes of hikers, and even a conference center.

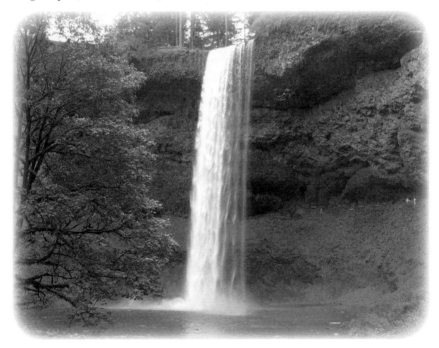

South Falls, the tallest waterfall in the park, is just a few minutes' walk from the lodge.

You see, most folks visit the park only on a nice-weather weekend. And they focus on the area around the South Falls Lodge. And yes, it can get crowded then and there. But even on a summer Saturday, a little hiking will get you away from the crowds.

Ah, but if you can slip away on a slightly damp day, or during the week, it's like a whole different place. Then it may be only you and the waterfalls—10 of them on an easy 7-mile hike. There are even three falls that you can walk behind, and all of this in a steep, wooded canyon that offers wildflowers in the spring, shade in the summer, colors in the fall, and water everywhere in the winter.

The nice thing about the Canyon Trail, more romantically known as the Trail of Ten Falls, is that it offers several opportunities to head back to the lodge. You can walk for 0.5 mile, the full 7, or almost any distance in between. Away from the canyon there are horse trails, picnic and swimming areas, and the lodge with its gift shop and coffee shop.

It's those other accommodations that also attract crowds. But one of the great things about living around Portland is knowing that at all times of year, and in almost all weather, you can slip away to the wonderful world of waterfalls and find a quiet place to be with the waters.

↵ essentials

☐ 20024 Silver Falls Highway SE, Sublimity, OR 97385

☎ (800) 551-6949 🌐 oregonstateparks.org/park_211.php

$ Use fee: $5/day, $30/year, or $50/two years. Buy day passes at the park; for annual/biannual passes, call the phone number above or visit tinyurl.com/dayuse-permit-vendors.

🕐 **November–February:** Daily, 8 a.m.–5 p.m. **March and October:** Daily, 8 a.m.–6 p.m. **April and September:** Daily, 8 a.m.–8 p.m. **May:** Daily, 8 a.m.–9 p.m. **June–August:** Daily, 7 a.m.–9 p.m.

🚍 n/a

peaceful place 77

SMITH AND BYBEE WETLANDS NATURAL AREA
Delta Park, North Portland (MAP 2)
CATEGORY ⌣ outdoor habitats ⭐ ⭐ ⭐

*S*ometimes we humans just need to clean up our messes. In the case of Smith and Bybee Lakes, we've done quite well for ourselves, and for our wildlife friends.

When it was only Native Americans around here, the whole area now called Delta Park was a floodplain, which every year would fill up with water from the Willamette and Columbia Rivers. Then we dredged it, put in pipes, built levees, and all around trashed the place. But now we're bringing some of it back.

Looking into Bird World

Ducks Unlimited put in a water-control structure that is now run by the Metro government, so that in winter and spring, water is held there, and in summer it comes and goes with the tides. A nearby former landfill is now grassland. Native trees have been replanted along the lakeshore to keep out invasive grasses.

The result is a 2,000-acre haven for birds, turtles, beavers, coyotes, swamps, old trees, frogs, you name it. But mainly birds, and mainly in winter. The Audubon Society of Portland (see page 5) lists more than a dozen species that you can spot hundreds of, including cormorants, egrets, and all manner of ducks. They also report seeing thousands of Canada geese and green-winged teals.

A short, paved trail, starting at the parking lot, goes out between the lakes and visits two wildlife-viewing stands. There's also a nice boat ramp, and the paddling is outstanding. Check the Web for events hosted by Metro or other groups.

So we're trying to make up for old behaviors. The birds seem to appreciate it, but we've also given ourselves a grassy, wet, quiet space, where you can briefly forget the surrounding industry.

essentials

⌨ 5300 North Marine Drive, Portland, OR 97203

ⓒ **Metro Park Environmental Services:** (503) 797-1850 (press *2* for Metro's natural areas)

⊕ tinyurl.com/smithbybeewetlands

$ Free

⊙ Daily, sunrise–sunset

🚌 **TriMet Bus:** Marine Drive Shuttle (Monday–Friday only)

peaceful place 78

STEIGERWALD LAKE NATIONAL WILDLIFE REFUGE
Washougal, Washington (MAP 8)
CATEGORY ↵ outdoor habitats ✪ ✪ ✪

*E*ntering the Columbia River Gorge in Washington couldn't be more sudden or appropriate. You pass a sewage-treatment plant, and suddenly there's a view ahead and a big field on the right.

Most of us, at that point, exhale and speed up. But that seemingly unremarkable field is a marvel unto itself, filled with life and beauty. Called Steigerwald Lake National Wildlife Refuge, it opened a couple of years ago. Go and have a look around the next time you're passing through.

Simply gazing at the lakeshore is a stress buster.

First it will seem as though you're simply walking along a field. But birdsong will resound all around you, tall grasses will be swirling in the breeze, and you'll probably catch sight of a heron or a hawk moving around. Then you'll notice water coursing through the grasses, and maybe ducks or geese swimming about. (Guided birding hikes take place in May each year.)

After 0.5 mile of flat walking on a nice trail, you'll come to a patch of woods and more water in it, and perhaps see some deer. Beyond those woods is a much bigger lake: Steigerwald itself, where birds are abundant and a bridge spans a corner of it. Beyond this, barely a mile from your car, a levee road runs along the Columbia for a while.

To keep things chill for the wildlife, you're not allowed to bring a dog or to bike or jog. I approve wholeheartedly. Get out of the car, walk along quietly, watch and listen for animals, try to slow down, and enter their world for a little while.

✎ essentials

✉	35510 SE Evergreen Highway, Washougal, WA 98671
✆	(360) 887-4106
✈	fws.gov/ridgefieldrefuges/steigerwaldlake
$	Free
◷	Daily, sunrise–sunset
🚌	n/a

peaceful place 79

TABORSPACE

Belmont, Southeast Portland (MAP 4)

CATEGORY ⌣ reading rooms ⭐ ⭐

*C*offee is a religion in Portland. TaborSpace takes that devotion to a whole new level.

When you sit down for a cup of Ristretto Roasters hand-roasted artisanal brew at one of the wood tables, or maybe a couch in the corner, or perhaps over by the fireplace, you are sitting in the old bell tower of Mount Tabor Presbyterian Church. The light is filtered through 100-year-old stained glass windows adorned with biblical quotations. Old-growth beams soar 30 feet over your head. A cross hangs above the hearth.

A cup of joe at TaborSpace is a religious experience.

The room was closed to the public for 40 years and used for storage until a new pastor realized the church needed, well, *something*. It lacked connection to the community; the community needed a gathering space. Put it together, and in 2009 the church opened TaborSpace: part coffee shop, part community center, and part performance space. Here you'll find rooms for rent, healing services, live music, and pay-what-you-want coffee and pastries.

The place seats 100 people, but I've never seen more than a handful there. (I'm told that it gets busy in the morning with commuters.) It's big enough for you to find your own space, small enough that you can hear the kids playing, and spiritual enough to remind you that we're meant to be together in what the mission statement calls "healthy, welcoming, spirit-filled community, in a beautiful enriching space—one cup of coffee at a time!"

Amen!

essentials

⌨ 5441 SE Belmont Street, Portland, OR 97215

✆ (503) 238-3904

🌐 taborspace.org

$ **Coffee and pastries:** Pay what you want; **Lunch:** $2–$4

🕐 Monday–Friday, 7:30 a.m.–4:30 p.m.; Saturday, 8:30 a.m.–4:30 p.m.; closed holidays

🚌 **TriMet Bus:** #15 to SE 55th Avenue and Belmont Street

peaceful place 80

TANNER SPRINGS PARK

Pearl District, Central Portland (MAP 1)

CATEGORY ⌣ parks & gardens ⭐

ater trickling. Kids giggling. Flowers blooming. Tall grass swaying in the breeze. A duck paddling on a pond. Where are we? The corner of NW 11th Avenue and Marshall Street, in Tanner Springs Park.

One wouldn't normally associate the Pearl District with *tranquil*, much less *nature*, but over here at the north end, you're kind of on the edge of town, over by the railroad tracks, across from the river. It's where the streetcar turns west and heads into the industrial area, then off to NW 23rd Avenue. A few vacant lots still stand over here.

Walkway and pond at Tanner Springs Park, often the site of photo shoots

And every evening, as downtown drains of its day workers, this quiet little corner of the Pearl becomes downright serene, with traffic clearing out and sunset colors spreading over the Fremont Bridge. Then Tanner Springs Park—the one with the pond and the grass and the wall of old rail ties—becomes a hub of relaxation.

It's also the very essence of the Pearl: reclaimed from rail yards, it's completely artificial but brilliantly designed. It's a giant water-reclamation project, with two "springs" feeding creeks that gurgle through manufactured meadows. Folks come to nap, picnic, read, or lie in the grass, admiring irises and ducks.

You might see wedding parties or fashion shoots going on, but even during the day the park remains a quiet city block. A friend who lives across the street said he once saw an osprey come in for a fish. And on one moonlit evening walk, I saw a heron in the pond stalking fish while two mallards slept in the shore grass. Watching the heron's slow, graceful movements, no more than 20 feet away from me, I thought to myself, *What are you doing in the middle of the city?* Then the answer came to me: he was simply accepting our invitation.

⌣ essentials

≡ Bounded by NW 10th and 11th Avenues and NW Marshall and Northrup Streets, Portland, OR 97209; **GPS coordinates:** N45° 31.870' W122° 40.915'

ℭ **Portland Parks & Recreation:** (503) 823-7529
 Friends of Tanner Springs Park: (503) 823-5121

🌐 tinyurl.com/tannerspringspark

$ Free

🕐 Daily, 5 a.m.–midnight

🚋 **Portland Streetcar:** NW 10th Avenue and Marshall Street
 TriMet Bus: #77 to NW 10th Avenue and Marshall Street

peaceful place 81

THE TAO OF TEA

Sunnyside, Southeast Portland (MAP 4: SEE 81A); Old Town, Central Portland (MAP 1: SEE 81B)

CATEGORY ❁ shops & services ✪ ✪

*W*hat's more soothing than a cup of tea? Well, it might be the sound of water falling. Or soft light. Or the image of a Buddha in meditation. A little something sweet to eat.

All these things exist in abundance at The Tao of Tea, a place that combines a soft-lit café with a meditation garden and teahouse. Have a seat in a cozy booth at the feet of the Buddha, or on a stool by a wooden table next to a burbling fountain, or at an intimate table for two by the window. The dozens of teas and herbals hail from such countries as India, Sri Lanka, China, and Nepal, from regions with mystical names: Assam, Darjeeling, Ratnapura, and Uji.

The server will bring your tea in a ceramic pot, let you know exactly how long to let it steep depending on what kind you've

At The Tao of Tea, you can sit and sip or take some home with you to brew.

ordered, and answer any questions you may have along the way. Drinking tea this way connects you to far-off regions while also bringing you into the moment as you wait for the drink to be just right. You can also buy tea or tea wares to take home with you (there's an online store, too).

Relax, breathe in the calm, and settle into yourself and the now, letting the warmth spread within you. Seek the Tao in the tea.

⌣ essentials

☞ **This location (Belmont):** 3430 SE Belmont Street, Portland, OR 97214
Lan Su Chinese Garden (see page 85): 239 NW Everett Street, Portland, OR 97209

✆ **Belmont:** (503) 736-0119; **Lan Su:** (503) 224-8455

🌐 taooftea.com

$ **Tea by the pot:** $4–$25. **Sweet and savory bites:** $4–$9. **Teas for home brewing:** $1.75/ounce–$45/canister. **Tea wares and gifts:** $3–$155

🕐 Daily, 11 a.m.–11 p.m.

🚌 **Belmont: TriMet Bus:** #15 to SE Belmont Street and 34th Avenue
Lan Su: MAX Light Rail: Old Town/Chinatown
Lan Su: TriMet Bus: #4, #8, #16, #35, #44, or #77 to NW Everett and Second Streets

peaceful place 82

TARA THAI NORTHWEST
Nob Hill, Northwest Portland (MAP 6)
CATEGORY ↵ quiet tables ✪ ✪

*P*ortland has so many Thai restaurants that my buddies and I used to make bets about any eatery under construction: we each had to guess whether it would be a Thai place, a bento place, or a coffee shop. And honestly, I can't tell which Thai place has the best food because I love them all. Bad Thai food is good as far as I'm concerned.

But none of them has a deck quite like the one at Tara Thai on NW 23rd Avenue. And absolutely nobody—no restaurant, no home, nobody—has a tree like they do.

Tara Thai's lovely deck is shaded by Portland's most awesome tree.

If you think for a moment about NW 23rd, over by Overton Street, you can probably picture this tree. I guarantee that you've noticed it. It's an Oregon white oak, 80 feet high, 86 feet wide, and 14 feet around. I have no idea how old it is, but the species can live 500 years, and this is a really big one.

No matter how many times I see it, my brain stops working for a few moments, and all I can do is stare up at it stupidly and say, "Damn!" It covers the whole restaurant, and the street, and some of the yard across the street. The immensity of its presence goes beyond the physical and into the spiritual. I can't be near it without slowing down and slipping, just a little, out of my sense of time and space.

No, I didn't write this while drinking a specialty cocktail at Tara Thai, nor after eating one of its Lao specialties such as *pla neung*. (Of course, I'd be remiss if I didn't describe it. Per the menu: Halibut marinated and steamed with fresh lime juice, ginger, pickled garlic, and green and white onions, delicately arranged over a bed of tofu and topped with fresh ginger, baby bok choy, and basil.)

Hmm. Maybe it's time to go sit beneath that tree again. . . .

⌣ essentials

✉	1310 NW 23rd Avenue, Portland, OR 97210
☎	(503) 222-7840
🌐	tarathainorthwest.com
$	$3.50–$19
🕐	Tuesday–Thursday, 11 a.m.–3 p.m. and 4–9 p.m.; Friday 11 a.m.–3 p.m. and 4–9:30 p.m.; Saturday, noon–9:30 p.m.; Sunday, noon–8:30 p.m.
🚍	**Portland Streetcar:** NW 23rd Avenue and Marshall Street **TriMet Bus:** #15 or #77 to NW 23rd Avenue and Overton Street

TEAZONE & CAMELLIA LOUNGE
Pearl District, Central Portland (MAP 1)
CATEGORY ↶ quiet tables ✪ ✪

*R*ight in the heart of the Pearl, with a streetcar rumbling by and people walking their dogs up and down the sidewalks, you'll find this little bit of tranquility. Eastern music plays softly, pastries call, and more than 100 loose-leaf teas await.

And yet there are layers. There are the sidewalk tables, where you can sit under an umbrella and watch the world go by while noshing on your sandwich, quiche, salad, or even Sunday brunch. Inside is the haven of tea, including bubble teas, tea lattes, and smoothies. The scene resembles a Mediterranean patio café.

This comfy couch in the Camellia Lounge is the perfect spot for grooving to live music.

Then there's the back room, called the Camellia Lounge. By day it's about the coziest place in town to grab some couch or get your laptop out for a quiet retreat from the street. By night it turns into the most intimate music venue in town, usually featuring a jazz combo or a singer-songwriter.

So even when the band is on stage, this place invites you to sit down, slow down, sip something nice, and relax. The world outside will go on about its business. *We're* in the tea zone.

⌣ essentials

⊟ 510 NW 11th Avenue, Portland, OR 97209

℃ (503) 221-2130

🌐 teazone.com

$ $3.50–$12

🕐 Sunday, 10 a.m.–8 p.m.; Monday, 8 a.m.–7 p.m.; Tuesday–Friday, 8 a.m.–midnight; Saturday, 10 a.m.–midnight

🚊 **Portland Streetcar:** NW 10th Avenue and Glisan Street
 TriMet Bus: #17 to NW 12th Avenue and Glisan Street

peaceful place 84

TILLAMOOK FOREST CENTER

Tillamook, Oregon (MAP 8)

CATEGORY ↙ museums & galleries ★ ★

*I*t's hard to imagine the destruction that happened one day in 1933, when what's now called the Tillamook Forest essentially blew up. A fire had burned 40,000 acres over 10 days, but then an east wind blew, conditions were perfect, and in 20 hours the fire exploded to 240,000 acres. A mushroom cloud rose tens of thousands of feet in the air, and ash fell on ships 500 miles out at sea.

A "six-year curse" brought more fires in 1939, 1945, and 1951; when all was said and done, the devastation spread for miles. In most places, the fire was so hot that there was no

The Wilson River flows behind the Tillamook Forest Center.

vegetation to grow back at all. But a massive reforestation effort was undertaken, and in 1973 the Tillamook Burn, as it was called, was rededicated as Tillamook State Forest.

All of this story is told very well at the Tillamook Forest Center, where you'll also find a movie about the burn, displays on life in the forest, a scavenger hunt for the kids, and a re-created fire-lookout tower that gets you up into the tree canopy.

That's all well and good, but this is really about the forest. Behind the museum, a lovely bridge spans the Wilson River. On the far side, in the green-again splendor of woods, a trail runs for 21 miles through the heart of what once exploded in flame. All along there you'll find benches and lookout spots and other patches of peace.

It's really remarkable how many people were involved, how hard they worked, and how thoroughly the forest came back. Where once there was fire and smoke, today there's water, foliage, and serene places to sit and listen to the birds.

essentials

✉	45500 Wilson River Highway, Tillamook, OR 97141
✆	(503) 815-6800
➤	tillamookforestcenter.org
$	Free; donations accepted
🕐	**May–Mid-September:** Daily, 10 a.m.–5 p.m. **Mid-September–April:** Wednesday–Sunday, 10 a.m.–4 p.m. Closed on major holidays.
🚌	n/a

peaceful place 85

TORII MOR WINERY

Dundee, Oregon (MAP 8)

CATEGORY ↶ day trips & overnights ✪ ✪

*D*riving along the winding gravel road out to Torii Mor, you might start to think that you're in the hills of Tuscany. Your vista includes rolling hills covered in grapevines, big old trees marking property lines, patches of forest, tiny creeks, and the occasional sheep or cow calmly grazing.

Then, when you arrive, you might think that you're in Japan, as you're greeted by a Japanese garden. Stepping into the tasting room, you'll feel almost as if you're in

The views from the deck are even better with a glass in hand.

someone's home, with couches and a spacious deck looking out toward the garden. And it all comes together when you stroll to the larger deck down the hill. There, you look out at the hills and valley and vineyards and simply feel grateful that such a place is so close to Portland.

A word about the peacefulness of the place: even the staff suggests that it can be a carnival on summer weekends, so aim for a weekday or sometime in the fall, when the colors will be rich and the temperatures cool.

Torii Mor's story goes back to the relatively early days of Oregon wine making; its first vineyard was planted in 1972, and its first vintage came out in 1993. Today it's a Leadership in Energy and Environmental Design–certified haven of sustainability and recycling, with all sorts of installations for saving water and reusing construction materials.

And then there's the Japanese Garden, which as near as I can tell is just for decoration. The name Torii Mor is a multicultural hybrid—*torii* is Japanese for "garden gate," *mor* Norwegian for "mother." So Torii Mor is a gateway to Mother Earth, and in our case a wonderful gateway into that part of Oregon that just might make you think you're someplace else.

⌣ː essentials

▤	**Winery:** 18365 NE Fairview Drive, Dundee, OR 97115 **Tasting room:** 18323 NE Fairview Drive, Dundee, OR 97115
☎	**Winery:** (800) 839-5004; **Tasting room:** (503) 538-2279
🌐	toriimorwinery.com
$	$10 to taste six wines; $25 per person (reservations and prepayment required) for a tour that includes tasting
🕐	Daily, 11 a.m.–5 p.m.; closed January 1, Thanksgiving, and December 25; reservations required for parties of seven or more.
🚌	n/a

peaceful place 86

TOWNSHEND'S TEA COMPANY

Alberta Arts/Concordia, Northeast Portland (MAP 3: SEE 86A); Division, Southeast Portland (MAP 4: SEE 86B)

CATEGORY ↵ shops & services ✪ ✪

*N*ortheast Alberta Street can get pretty nuts, especially on Last Thursdays, a neighborhood event that takes place during nice-weather months. That's when it explodes into an artsy frenzy, with street performers, vendors, drunks, and other assorted wackiness.

Even the rest of the year, it's a happening place, and an up-and-coming neighborhood that's clearly already here. And every neighborhood needs a calm center, a place where folks can simply sit quietly and chill out, and—in this case—have a nice cup of tea.

Townshend's is a tea-rific oasis amid the madness of Alberta Street.

Still, Townshend's is really more than a teahouse. It sells tea in 10 categories. It also brews its own line of kombucha (a fermented tea–sugar concoction purported to possess wondrous health benefits), and it offers it in six versions, including Clear Mind.

It all started at the University of Oregon, when the eventual owner wanted to combine coffeehouse culture with top-grade loose-leaf tea. The Alberta shop opened in 2006, and today you can get a cup or pot of dozens of kinds of tea (there's also a Townshend's in Portland's Hollywood District and another in Bend). Don't know what you want? Describe what you're in the mood for and they'll set you up. It can be a very educational experience, and the staff is always very friendly.

By the way, the place is named for Charles Townshend, the Englishman who passed the laws that set off the Boston Tea Party. The owner says he "likes the idea of using the name of the man responsible for tea's underdog status."

Take a seat in the front room and watch the colorful Alberta scene unfold outside, or go downstairs to the vintage basement, where you'll find a perfectly Portland mix of couches, Moroccan pillows, Ms. Pac-Man, and goofy faux panoramas in the below-street-level windows. And be grateful that Portland isn't all about coffee all the time.

⌣ essentials

☞ **Alberta St.:** 2223 NE Alberta Street, Portland, OR 97211
Division St.: 3531 SE Division Street, Portland, OR 97202

☏ **Alberta St.:** (503) 445-6699; **Division St.:** (503) 236-7772

⊕ townshendstea.com

$ $2–$5 per person

☽ Daily, 9 a.m.–10 p.m.

🚌 **Alberta St.: TriMet Bus:** #72 to NE Alberta Street and 21st Avenue or #9 to NE Alberta Street and 27th Avenue
Division St.: TriMet Bus: #4 to SE Division Street and 35th Place

peaceful place 87

TRINITY EPISCOPAL CATHEDRAL LABYRINTH
Alphabet District, Northwest Portland (MAP 6)
CATEGORY ↙ spiritual enclaves ✪ ✪ ✪

*S*imply walk the path.

Most spiritual traditions boil down to something like that. Do what's in front of you. Follow God's will. Turn it over to your Higher Power. Throughout the ages, walking the labyrinth has been a symbol of this most basic of spiritual practices. One walks the path to the center, and then returns to the world.

Portland is blessed with several labyrinths: the two best are the outdoors path at The Grotto (see page 64) and this one, inlaid into the wooden floor of Kempton Hall at Trinity Episcopal Cathedral.

Embark on your own inner journey at Trinity Episcopal's Public Labyrinth Walk.

On the third Monday of each month, you're invited to participate in the Public Labyrinth Walk. Volunteers dim the lights and scatter candles around Kempton; soothing music and sweet incense fill the air, and silent walkers follow the path, metaphorically and literally, into the center, then back.

If you've never walked a labyrinth, fear not; it isn't a maze, nor is there a right or wrong way to do it. We all follow the path in our own way. Silence is requested and donations appreciated, but newcomers are made to feel welcome.

You might pick up a stone with a message or inspiration to carry along. You might meditate before or after walking. You might focus on leaving a personal struggle in the center. You might go quickly; you might go slowly.

You'll soon forget that Burnside Street is a block away, that you're in the middle of a major city, that your worries are waiting for you at the door. Maybe it's all an illusion anyway.

Simply walk the path.

✐ essentials

⌸ 147 NW 19th Avenue, Portland, OR 97209

✆ (503) 222-9811

🌐 trinity-episcopal.org

$ Free; donations accepted

🕐 Third Monday of each month, 4–9 p.m.

🚍 **MAX Light Rail:** Blue Line to Jeld-Wen Field
TriMet Bus: #15 or #20 to West Burnside Street and NW 19th Avenue

peaceful place 88

TRIPLE FALLS HIKE

Columbia River Gorge, Oregon (MAP 8)

CATEGORY ↲ enchanting walks ✪ ✪

*O*ut on the old highway, beyond the madness of Multnomah Falls, cascades another waterfall called Horsetail. It's worth a stop on its own, especially on a hot summer day, when the blast of its spray will cool you off.

Triple Falls is actually one creek, Oneonta, split into three.

Ah, but there's also a trail there, heading up and to the left. It's a little steep at first, gaining about 400 feet; then there's a right turn, and then it mellows out and cruises along the cliff face for a while. Just under 0.5 mile from your car, the trail ducks into a little cove, and there's this really cool moment when you see another waterfall, previously hidden. It seems to shoot right out of the wall and into a pool where you think you might see elves playing or hobbits dancing. And the trail goes behind it!

You can go back there and enjoy the trickles of water as well as the soothing sound of

the splash. And then you can keep going, for there's more: a 4-mile round-trip hike, if you want.

Give it another mostly flat mile, with more views of the Columbia opening up, and you'll pass a "weeping wall" of moss and dripping water, and then come to the top of Oneonta Gorge, where you'll cross a raging creek on a metal bridge between two waterfalls.

Of course, you've now left 95% of the people behind, and if it's not a weekend, you'll probably be alone. And if you can give it 1 more mile (gaining another 400 feet along the way), you'll reach a spectacular viewpoint of Triple Falls, where one creek splits into three and plunges into a pool surrounded by rock, moss, and trees.

Cross a new bridge above the falls, and where the trail keeps going, look for a creekside hangout where you can enjoy a picnic and soak your feet in the cool mountain water. The trail from here is all up and without views for a long time, so enjoy this little moment of water-filled wonder, and be glad you stopped. And you'll be glad you left the car and the crowds for a little walk.

⌣ essentials

▤ From Portland, drive east on I-84 for 21 miles. At Exit 24/Bridal Veil, turn left onto the Historic Columbia River Highway and continue 5.2 miles to the signed parking area at Horsetail Falls. **GPS coordinates:** N45° 34.540' W122° 6.595'

☏ (541) 308-1700

🌐 portlandhikersfieldguide.org/wiki/triple_falls_hike or nwhiker.com/CGNSAHike17.html

$ Free

🕓 24/7, but not recommended after dark, so be sure to time your walk so that you complete it within daylight hours.

🚌 n/a

peaceful place 89

TRYON CREEK STATE NATURAL AREA

Collins View, Southwest Portland (MAP 5)

CATEGORY ⌣ urban surprises ✪ ✪

You'll find peaceful paths aplenty at Tryon Creek State Natural Area.

photographed by Elisa Pehlke

onsider the steelhead trout. It's a rainbow trout, lovely with its speckled red sides and lush green back, tough enough to go back and forth from the ocean to freshwater more than once in its lifetime, and wily enough to be among the hardest fish to catch. It is, in other words, all that makes nature grand: beautiful, wild, and elusive.

Now consider Tryon Creek in southwest Portland. It's less than 5 miles long and barely 10 feet wide, starts near Multnomah Village and I-5, and merges with the Willamette River in the town of Lake Oswego. This is hardly wilderness. In fact, before it meets the Willamette, Tryon Creek flows through a 200-foot culvert and next to a wastewater treatment plant.

And yet there are steelhead in Tryon Creek. And some of them make it up into Tryon Creek State Natural Area.

Your odds of seeing one of these wanderers is quite slim, but at all times of year you can step into their world, right off Boones Ferry Road. It's 645 acres of what used to be—a wooded ravine with creeks, trees, flowers, and animals. You can sit in a shelter, walk flat paths, ride a horse, push a stroller or wheelchair on a paved loop, follow a ranger around, or wander off on your own.

You're sure to see nature in all its grandeur, no matter what time of year. And if you're lucky, you might see owls, woodpeckers, rabbits, a coyote, or even (if it's winter) one of those elusive steelheads.

✌ essentials

⌨ 11321 SW Terwilliger Boulevard, Portland, OR 97219

✆ **Tryon Creek State Natural Area:** (503) 636-9886
 Friends of Tryon Creek State Park: (503) 636-4398

🌐 oregonstateparks.org/park_144.php

$ Free

🕒 **Park:** Daily, 7 a.m.–sunset. **Nature Center:** Daily, 9 a.m.–4 p.m.

🚌 **TriMet Bus:** #39 to SW Terwilliger Boulevard and Second Avenue or SW Terwilliger Boulevard and Maplecrest Drive

peaceful place 90

TRYON LIFE COMMUNITY FARM

Collins View, Southwest Portland (MAP 5)

CATEGORY ↙ urban surprises ✪ ✪ ✪

*I*t would be one thing, and a darn cool one at that, to say that we have a working farm smack in the middle of Portland. And we do. But Tryon Life Community Farm isn't just a farm that never got sold off and divided up; it was saved from development by a wave of community support in 2005. Today it isn't so much a farm as it is an ongoing experiment in, and demonstration of, "conservation of natural resources and public greenspace [and] actual enhancement of native ecosystems."

Tryon Life's outdoor cooking area

Check out its website and read through its story, and you'll often see words such as *sustainable* and *conservation* and *permaculture,* and not just in reference to the land. Although Tryon Life sits in a thickly residential part of town, it's unseen from the road, nestled against Tryon Creek State Natural Area (see previous profile). To walk down here from Boones Ferry Road feels a little like heading out to Breitenbush Hot Springs—only with goats.

Yes, goats and chickens and dogs wander around, as do bees and birds and people. It's a community of many species, all trying to work together. And its existence is based on an invitation to join in that life and work.

The farm is open to the public for self-guided tours several times a week, but there is also an abundance of work parties, group-visit times, educational workshops, and an open invitation to all communities of faith to bring their blessings and wisdom.

In other words, it's a whole lot more than a farm. It's a retreat, a trip back in time, and, they hope—let us all hope—a trip into a better, healthier future.

⌣ essentials

📧 11640 SW Boones Ferry Road, Portland, OR 97219

📞 (503) 245-3847

🌐 tryonfarm.org

$ Donations requested

🕐 Friday and Sunday, 11 a.m.–4:30 p.m.; Saturday, 11 a.m.–3 p.m.

🚌 **TriMet Bus:** #38 to SW Boones Ferry Road and Stephenson Street (rush hours only)

peaceful place 91

TUALATIN HILLS NATURE PARK

Beaverton, Oregon (MAP 8)

CATEGORY ∽ outdoor habitats ✪ ✪

*S*o often, we think of ourselves as living "in town" and nature as existing "out there." We might be driving along a busy road, watching traffic and storefronts, lost in the radio or conversation, and briefly realize that we're crossing a creek, or there's an "empty" field or a patch of forest over there.

Forest canopy creates a verdant tunnel over this trail at Tualatin Hills Nature Park.

In fact, those woods and creeks and fields harbor little pockets of nature—not pristine, but tranquil, lovely, and inviting. Tualatin Hills Nature Park is a fairly large example of this. Surrounded by sprawling suburbia, the park is 222 acres of forest, wetlands, creeks, ponds, and meadows. Four miles of trails (1.5 miles of them paved) wander around and through it, and even on relatively busy weekend days, you can find your own little patch of nature to enjoy.

I was in the area once to meet a friend for lunch. I got there early and had an hour to

kill. I drove over to the park and checked in at the interpretive center, where I was told that several people had seen the resident barn owl along a certain trail. It was over by the Big Pond, they told me.

I never saw the owl that day, but I was serenaded by all sorts of songbirds. I watched ducks paddle around the pond. I heard the laughter of children through the trees. And I felt the soft soil under my feet.

As I headed back into the city, I made it a point to turn toward the woods, bow slightly, and say thanks for the reminder.

☙ essentials

⊞ 15655 SW Millikan Way, Beaverton, OR 97006

📞 (503) 629-6350

🌐 thprd.org/facilities/naturepark

$ Free

🕐 **Park:** Daily, sunrise–sunset. **Interpretive Center: February–November:** Monday–Friday, 8:30 a.m.–5 p.m.; Saturday–Sunday, 9 a.m.–5 p.m. **December–January:** Monday–Friday, 8:30 a.m.–4 p.m.; Saturday–Sunday, 9 a.m.–4 p.m.

🚌 **MAX Light Rail:** Blue Line to Merlo Road/158th Station; the park's Oak Trail lies across the tracks from the station.

peaceful place 92

TUALATIN RIVER NATIONAL WILDLIFE REFUGE
Sherwood, Oregon (MAP 8)
CATEGORY ↲ outdoor habitats ✪ ✪ ✪

*P*ortlanders are certainly aware that there is such a thing as the Tualatin River. After all, they cross it on interstate bridges around town, or on smaller roads in Washington County. But most probably don't realize that it's 83 miles long, drains an area of 712 square miles, and in at least two places is a serious wildlife haven.

One of those is the Atfalati Unit of the Tualatin River Wildlife Refuge, which is about a mile from a cluster of strip malls and big-box stores along OR 99 in Sherwood. You

A side pond at Tualatin River National Wildlife Refuge

can even take a city bus there from downtown Portland. Thankfully, among the many amazing things about migratory birds is that, eventually, they will accept things such as highways and buses and go on about their business.

At this part of the refuge, at any time of year, you really get a sense of visiting the birds' world. For more than 20 years, managers have been restoring this floodplain to as natural a state as they can, and apparently it's working: the refuge claims 200 species of birds, 50 species of mammals, 25 species of reptiles, and a host of bugs, plants, and fish.

Neither dogs nor joggers are allowed, so you need to slow it down. But that's perfect. Trails wander along through woods or out in the open, past creeks and marshes, and occasionally you'll see a group of people with binoculars pointing, probably at a bird. The largest number of flying visitors are in the winter, but many songbirds come in the summer to breed. Other attractions: monthly flower walks and nighttime walks, a Bird Festival every May, and a fantastic Wildlife Center.

So it's really a place where humans and animals have figured out a way to get along with each other. And the more you can act like them—slow, patient, and aware—the more you get to partake in their peace and simplicity.

⌣ essentials

▤ 19255 SW Pacific Highway (Oregon Route 99W), Sherwood, OR 97140

☏ (503) 625-5944

🌐 fws.gov/tualatinriver or friendsoftualatinrefuge.org

$ Free, though there may be a fee in the future; no pets allowed.

🕐 **Refuge:** Daily, sunrise–sunset. **Wildlife Center:** Monday–Thursday, 8 a.m.–4 p.m.; Friday, 9 a.m.–3:30 p.m.

🚌 **TriMet Bus:** #12 to Tualatin River National Wildlife Refuge

peaceful place 93

UNION STATION

Old Town, Central Portland (MAP 1)

CATEGORY ⌣ urban surprises ✪ ✪ ✪

*T*here is a magical moment right after a train has left Union Station. The last announcement has been made; the last passengers have shuffled out the doors, bound for Seattle or Los Angeles or Chicago; the last squeaky cart has rolled back to the

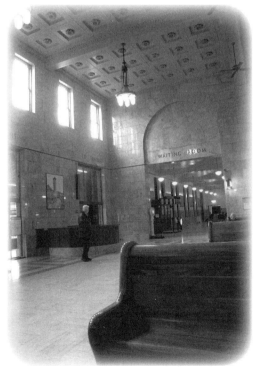

Calm between the trains: the Grand Hall at Union Station

baggage department. And then the Grand Hall, first opened in 1896, falls silent again and returns to its waiting state.

But it's not the usual silent state of, say, a library. The silence of a train station is pregnant with the energy of other places, of people going on journeys. The fact that one room is simultaneously occupied by people going to and coming from so many places, and that it has been for so long, means that some of that energy remains in the hall, and with the right attention you can almost feel it when they're gone.

There are other little secrets to find around the station, such as a courtyard of trees and

flowers, and a pedestrian bridge over the tracks, leading to condos over by the river. The area under the 100-year-old Broadway Bridge and behind the main post office has some little nooks to explore. But the real treasure is the Grand Hall.

I live and work near Union Station, and when I'm walking by, I will often drop in to sit on one of the big wooden benches for a bit and let my mind wander. I visit when all the people are there, because I love the sweet excitement of people getting on the road or being greeted by loved ones. But I also love that grand, expectant silence of the hall when they're gone. I close my eyes and imagine myself going with them, riding the rails, and I feel connected to the whole world all at once.

⌣ essentials

▣	800 NW Sixth Avenue, Portland, OR 97209
☎	(503) 273-4865
🌐	amtrak.com (click "Stations," then enter *PDX* under "Find a Station by Code")
$	Free
◷	Daily, 7:15 a.m.–9:15 p.m.
🚌	**MAX Light Rail:** Green or Yellow Line to NW Sixth Avenue and Hoyt Street **TriMet Bus:** #77 to Union Station or #9 to NW Broadway and Irving Street

peaceful place 94

VERITABLE QUANDARY

Downtown, Central Portland (MAP 1)

CATEGORY ⌣ quiet tables ⭐

*T*he VQ, as it's known around town, walks a line between fancy and casual. In fact, it does so in a classically Portland way. In many other cities, the place with the nice patio and the 200 wines and the glassed-in dining room, down by the bridge and riverside park, would be beyond the economic reach of most diners.

At the VQ, however, entrées at dinner and weekend brunch generally run around $15, and a bar menu (served from 3 p.m. on) is a little cheaper. The place gets busy at lunch and for after-work happy hour, and it's a favorite place to hit for a drink and a snack before a downtown show.

The feel is old-fashioned in a Portland-garden sort of way: the patio is lined with flowers, the dining room feels like the sunroom at some laid-back millionaire's house, and the menu is filled with Portland classics such as frittata with salmon, asparagus, chives, and crème fraîche (brunch); seafood stew with fish, mussels, clams, prawns, and calamari (dinner); and duck-confit spring rolls (at the bar).

But here's the scoop on seating: the dining room is lovely and manages to have several little private nooks. The patio is wonderful when the weather is nice. But it's the wine cellar you want, if you have a big group. It seats eight and is down a short flight of steps. Just call ahead for reservations.

You'll feel oh-so-cool down there, surrounded by the bottles at a big round table that no one else can get to. Important, well fed, and not broke . . . how Portland.

essentials

☰ 1220 SW First Avenue, Portland, OR 97204

☎ (503) 227-7342

🌐 veritablequandary.com

$ **Entrées:** $12–$29

🕐 **Lunch:** Monday–Friday, 11:30 a.m.–3 p.m. **Dinner:** Daily, 5–10 p.m. **Brunch:** Saturday–Sunday, 9:30 a.m.–3 p.m. **Bar:** Daily, 11:30 a.m.–3 p.m. and 5 p.m.–2:30 a.m. (bar menu available after 3 p.m.)

🚌 **TriMet Bus:** #4, #6, or #14 to SW Madison and First Avenue

peaceful place 95

VIETNAM VETERANS OF OREGON MEMORIAL
West Hills, Southwest Portland (MAP 5)
CATEGORY ᵔ parks & gardens ✪ ✪ ✪

As I write this, I have a nephew, David, serving in the Army in Afghanistan. I wasn't completely clear on his duties, but my sister assured me that they involved "getting shot at every day." It's my first experience with a loved one in combat, and as anybody can tell you, it changes everything about how you see war.

I was born in 1966, so I can't imagine what America was like in those days, watching on television as 50,000 or more of our sons and daughters, brothers and sisters, and dads and moms were getting killed or wounded or coming home changed forever. I know that my dad, normally given to understatement, once told me that it seemed as though America was coming apart at the seams.

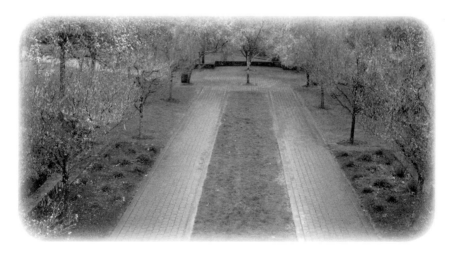

The Vietnam Veterans of Oregon Memorial serves as a peaceful reminder of a violent past.

This is why I'm grateful for the Vietnam Memorial in Washington Park. Not only does it honor the Oregonians who served and died in Vietnam, but it also tells some of the story of what was going on back here at home. And it recognizes the whole scope of the war, from the 1950s to the 1970s.

It's also set up as a spiral walkway to be done one-way, so you almost have to experience the whole thing. For each year, there's a display and a list of names—each one as loved as my nephew. And it's beautiful as a place to visit, with dogwoods all around, pear trees at the entrance to signify life and sacredness, and a fountain in the Garden of Solace to represent life, purity, and hope.

Maybe we'll never be without war. But may we never be without gratitude for the ones who served, honor for the ones who didn't make it, and places of serenity such as this to think of them.

⌣ essentials

✉	4000 SW Canyon Road, Portland, OR 97221
☎	(503) 823-7529
🌐	tinyurl.com/vvomemorial
$	Free
🕐	Daily, 5 a.m.–10 p.m.
🚆	**MAX Light Rail:** Red or Blue Line to Washington Park

peaceful place 96

WARRIOR ROCK TRAIL

Sauvie Island, Outer Northwest Portland (MAP 7)

CATEGORY ↶ historic sites ✪ ✪ ✪

*W*arrior Rock got its name when members of a 1792 English expedition up the Columbia found themselves on this rock, surrounded by dozens of native warriors. They cleverly made peace and lived to tell the tale.

Today Warrior Rock hosts Oregon's smallest lighthouse, built in 1899 at the end of an easy 7-mile out-and-back hike. But you don't have to walk all that way to get a sense of the place. Beyond the trailhead is a long, sandy beach where Meriwether Lewis and William Clark's Corps of Discovery are believed to have camped during their journey.

The trail to Warrior Rock is replete with scenes that evoke solitude and introspection.

The best time to come here is late summer—not just because it's a cool, shady, riverside retreat, but also because the trail is lined with a mind-boggling abundance of blackberries. Plus, at that time of year you can follow the beach nearly the whole distance to Warrior Rock.

As you wander along, either on the beach or the trail above it, look for animal tracks: raccoons, deer, coyote, and even feral cats are all common here. But those critters move around mostly at night, and if the hunters and fishermen aren't out, you may have the place to yourself. (*Note:* Waterfowl-hunting season generally runs September–January.)

Up on the trail, you'll pass through a world of blackberries, oaks, alders, and maples. After about 2.5 miles, at a point where the trail is right at the top of the bluff, look to the right for an old shipwreck on the beach. A few minutes later, you'll come to a large meadow; stay right for 0.2 mile to the lighthouse. Yet another beach lies beyond the light.

You might see fish jumping, you might see other wildlife, or you might see an ocean-going vessel steam by—and chances are that you'll see no other people at all.

∠ essentials

⌑ End of NW Reeder Road, Sauvie Island, Portland, OR 97231
 GPS coordinates for parking: N45° 48.521' W122° 47.893'

☎ (503) 621-3488

☞ sauvieisland.org/visitor-information/historical-attractions/warrior-rock-lighthouse

$ Parking, $7/day or $22/year. Passes available at Cracker Barrel Grocery, 15005 NW Sauvie Island Road, Portland, OR 97231; Reeder Beach RV Country Store, 26048 NW Reeder Road, Portland, OR 97231; and Oregon Department of Fish and Wildlife, 18330 NW Sauvie Island Road, Portland, OR 97231.

☽ Daily, sunrise–sunset; this is a 7-mile round-trip hike, so be sure to finish before dark.

🚌 n/a

peaceful place 97

WASHINGTON PARK INTERNATIONAL ROSE TEST GARDEN

West Hills, Southwest Portland (MAP 5)

CATEGORY 〜 parks & gardens ⭐ ⭐

℞ oses inspire intense feeling, and for good reason: they're beautiful, they're hardy but delicate, and they smell fantastic. They strike a balance between the scientific and the sensual—their scents and colors are the products of precise genetic manipulation, but they give us layfolk tremendous pleasure.

Don't miss the garden's cherries and daffodils in springtime.

Likewise, the phrase *test garden* sounds dry and dull in theory but packs a sensory punch in practice (in this case anyway). The International Rose Test Garden is a wonderland of terraces in the West Hills, hundreds of feet above the valley floor, with a commanding view of the city and Mount Hood, and more than 8,500 rose plants in more than 700 varieties.

Founded in 1917, the garden has since expanded to include several sections: the Gold Medal Garden of past award winners; the Test Garden itself, with about 200 cultivars per year; the Miniature Rose Garden; and the Royal Rosarian Garden. Another, the Queen's Walk, honors past queens of the Portland Rose Festival. Still another, the immensely charming Shakespeare Garden, beckons you to enjoy its shade trees, annuals and perennials beyond roses, and an organic, unmanicured design befitting a poet and romantic.

The garden can be nuts on a summer weekend—the roses usually bloom in early June—so get out on a weekday or early in the morning, when the sun is just coming over Mount Hood on the horizon. Bring a picnic if you like (the Shakespeare Garden is a perfect spot for this), or plan to wander around, marvel at the sheer number of blooms, and revel in the details. And, of course, enjoy those delicate smells—which, of course, by any other name would be as sweet.

⌣ essentials

✉	400 SW Kingston Avenue, Portland, OR 97205	☎	(503) 823-7529

🌐 tinyurl.com/rosetestgarden or rosegardenstore.org/thegardens.cfm

$ Free

🕙 Daily, 7:30 a.m.–9 p.m.

🚌 **TriMet Bus:** #63 to SW Fairview Boulevard and Kingston Avenue (only Monday–Friday) **Max Light Rail:** Blue or Red Line to Washington Park, and then (daily, Memorial Day–Labor Day or Saturday–Sunday, May, September, and October) take TriMet #83 to the garden

peaceful place 98

WHITAKER PONDS NATURE PARK

Columbia Corridor, Northeast Portland (MAP 3)

CATEGORY ⌣ parks & gardens ✪ ✪ ✪

*J*t's hard to think of a less likely place in Portland to go looking for wildlife and peace of mind. Whitaker Ponds, which also doesn't sound very impressive, is surrounded by warehouses and light industry on the north side of Columbia Boulevard. Even when you arrive—you have to park on the shoulder of NE 47th Avenue, outside a chain-link fence—you may be wondering why you bothered with this trip.

Whitaker Ponds Nature Park is small in size but big in scenery and nature.

And then you catch a glimpse of water through the trees, and you spy a dock and a mossy roof. Perhaps you hear a birdcall. Soon you're gazing upon as sweet a pond as you're likely to find in any countryside or wilderness area, and you may even forget about all the steel and noise around you.

Walk around a bit, and you'll see the Lewis and Clark Garden, which honors the explorers with plants mentioned in their journals and divided into sample ecological zones, from prairie to lowland forest. A mossy ecoroof sits atop a gazebo–picnic shelter with a view of the water. A trail crosses the outlet stream and snakes around the West Pond, through a replanted zone, and past a couple of baseball fields between the two ponds. A boat launch sits on nearby Whitaker Slough. You will also note a sign explaining that more than 500 Dumpsters of junk, including 2,000 tires, were hauled out of here to make this place what it is today.

I suggest going late in the day, maybe even in winter when it's raining a little. Walk around the pond, listen to the rain pattering on the water, and watch the ducks paddle around. You just might think that you're an explorer, as you stroll the area around camp as the sun goes down, checking out what plants and animals managed to survive in a harsh human environment.

⌣ essentials

🖃	7040 NE 47th Avenue, Portland, OR 97218
📞	(503) 823-7529
🌐	tinyurl.com/whitakerponds
$	Free
🕐	Daily, 5 a.m.–midnight
🚌	**TriMet Bus:** #75 to NE 47th Avenue and Columbia Boulevard

peaceful place 99

WILD ABANDON

Belmont, Southeast Portland (MAP 4)

CATEGORY ↵ quiet tables ⭐

*D*on't be fooled by the mostly tin exterior or the name: Wild Abandon is one of the coziest restaurants in town. In fact, it's cozy-goofy. And that's just inside. Out back is one of the most private dining patios around.

Wild Abandon's fabulous, funky interior

Owner Michael Cox says that the lush, dimly lit interior once housed Ginger's Sexy Sauna. (He claims that a customer told him he'd lost his virginity on the premises.) It's been cleaned up since then, but you'll still feel as though you're in a New Orleans basement bar—except the mural on the wall seems to be Druidic. The frosted Mexican light fixtures say 1970s. The sculpted hands holding candles on the walls are mildly creepy. Cox summed all this up for me and some friends: "garage-sale Baroque."

Yet it all works, and the menu fits the scene. It's a big part Italian and a small part

German, with a dash of Cajun and a sprinkling of down-home. Even vegetarians and vegans can find something tasty, whether it's dinner, happy hour, late-night dessert, or weekend brunch.

If it's summer, sit out back. Though you're surrounded by houses and right off busy Belmont Street, towering junipers shelter you. And the wood deck will make you feel like you're in somebody's backyard—which you kind of are, right behind their groovy, comfy, goofy '70s basement lounge.

essentials

⌨ 2411 SE Belmont Street, Portland, OR 97214

✆ (503) 232-4458

🌐 wildabandonrestaurant.com

$ **Dinner:** $10–25. **Brunch:** $8–$10.

🕐 **Dinner:** Monday, Wednesday, and Thursday, 4:30–9 p.m.; Friday, 4:30–10 p.m.; Saturday, 5:30–10 p.m.; Sunday, 5:30–9 p.m. **Brunch:** Saturday–Sunday, 9 a.m.–2 p.m.

🚌 **TriMet Bus:** #15 to SE Belmont Street and 23rd Avenue

peaceful place 100

WILLAMETTE MISSION STATE PARK

Gervais, Oregon (MAP 8)

CATEGORY ✎ historic sites ✪ ✪

*T*here's something so old-fashioned about this place. For one thing, the history of white people in Oregon kind of starts here. A Methodist mission was founded here in 1834 and was nearly the first settlement. So it brings up images of clearing land, planting gardens, and gathering food. In fact, there are still orchards around.

There's also the old-fashioned feel of picnics and nature walks, which is most of what the park offers. You can even rent a barbecue grill there, which is so quaint. You can spend the night in a tiny hiker/biker camp or a horse camp. And the largest black

At Willamette Mission State Park, you can picnic under a shade oak in open-sky country.

cottonwood in America is here: a 270-year-old behemoth that's 155 feet high, 110 feet wide at the top, and more than 26 feet around.

But my favorite thing about the park is the ferry. Technically, it isn't part of the park, but it's the best way to access it, after you drive over from OR 99W in Amity. This is the first place where a covered wagon crossed the Willamette, in 1844, and to ride the ferry is to experience a minute or two of a lost travel experience. You bounce your car onto it and off you go, usually with only a few other people. We get so distracted from nature and the river that it's nice, for once, to simply be out on the water, depending on basic technology to get across. The fact that sometimes the water is too high to run the ferry adds to the charm (the website, below, keeps you up-to-date on ferry closures).

Of course, landing on the far side and finding about 1,700 acres of trails, fruit-bearing trees, water, and picnic sites waiting for you is that much sweeter. Sometimes the old-fashioned way really is the best way.

↙ essentials

⌗ 10991 Wheatland Road NE, Gervais, OR 97026

📞 (800) 551-6949

🌐 oregonstateparks.org/park_139.php

$ **Use fee:** $5/day, $30/year, or $50/two years. Buy day passes at the park; for annual/biannual passes, call the phone number above or visit tinyurl.com/dayuse-permit-vendors. **Ferry:** $2 for vehicles less than 22 feet long.

🕐 Daily, sunrise–sunset

🚌 **Ferry status:** co.marion.or.us/pw/ferries/wheatland.htm
 Daily, 5:30 a.m.–9:45 p.m.; closed Thanksgiving and December 25

peaceful place 101

WORKING CLASS ACUPUNCTURE

Cully, Northeast Portland (MAP 3: SEE 101A);
Hillsdale, Southwest Portland (MAP 5: SEE 101B);
Lents, Southeast Portland (MAP 4: SEE 101C)

CATEGORY ↵ shops & services ✪ ✪ ✪

y Memphis mind was up in arms: *You're gonna let those goofy people stick needles in you?* I had to assure my Tennessee-raised self that people have been doing this for centuries, that it's for a book, and that nothing else was helping my back anyway.

Maybe you're a little like me, so perhaps you can let go of whatever images you have of acupuncture. Lose the fears of high costs, huge scary needles, pain, and discomfort. Replace them instead with a suggested donation, tiny needles you'll barely feel, and a reclining chair in a quiet, dimly lit room, where you lie still (with a blanket, even) for as long as you like.

Did you just feel yourself relax a little? Wait until you kick back in that recliner.

The scene at the original clinic on NE 57th Avenue—there are two others in Portland and a network across the country—can take some getting used to, since we don't generally get medical care in big rooms with other people. But since those people are all off in floating-body-land when you come in, it's really not a worry.

At your first appointment, the staff will walk you through the basics, such as "You don't have to *believe* for it to work; animals benefit from it, too." Then you tell the person what you're in for, even if it's multiple things, and pick a recliner. They'll come around and, yes, stick needles in you. Remember, doing it for centuries. . . .

Then you relax, maybe listen to some tunes, and even go to sleep if you want. Just make eye contact when you're ready to go. I can tell you this: I found the whole experience very soothing, and my back really did feel better.

essentials

Cully: 3526 NE 57th Avenue, Portland, OR 97213
Hillsdale: 4410 SW Beaverton-Hillsdale Highway, Portland, OR 97221
Lents: 5814 SE 92nd Avenue, Portland, OR 97266

Cully: (503) 335-9440; Hillsdale: (503) 244-7525; Lents: (503) 477-7115

workingclassacupuncture.org

$15–$35

Cully: Monday–Thursday, 8:30 a.m.–7:50 p.m.; Friday, 8:30 a.m.–6:50 p.m.; Saturday–
Sunday, 8:30 a.m.–5:50 p.m. Hillsdale: Monday, 1:30–6:50 p.m.; Tuesday and
Thursday, 9 a.m.–12:50 p.m. and 2–6:50 p.m.; Wednesday, 9 a.m.–1:50 p.m. and
3–6:50 p.m.; Friday–Saturday, 9 a.m.–12:50 p.m.; Sunday, 9 a.m.–2:20 p.m.
Lents: Monday, 1–6:50 p.m.; Tuesday and Thursday, 9 a.m.–1:50 p.m. and 3–6:50 p.m.;
Wednesday, 9 a.m.–6:50 p.m.; Friday–Saturday, 9 a.m.–12:50 p.m.;
Sunday, 9 a.m.–3:50 p.m.

Cully: TriMet Bus: #24 or #71 to NE 57th Avenue and Fremont Street
Hillsdale: TriMet Bus: #54 to SW Beaverton-Hillsdale Highway and 45th Avenue
Lents: TriMet Bus: #10 to SE Ellis Street and 92nd Avenue
Lents: Max Light Rail: Green Line to Lents Town Center/SE Foster Road

peaceful place 102

WORLD FORESTRY CENTER

West Hills, Southwest Portland (MAP 5)

CATEGORY ⌣ museums & galleries ⭐

I used to think that the Forestry Center and its museums must be shills for the logging industry. I'm happy to say that I was wrong.

Sure, there's some stuff about logging, but logging is part of what built this city and state. (Besides, young boys of all ages will enjoy playing the video game that eats trees like a monster.) I find the museum to be a celebration of that amazing thing called a forest: cradle of life, center of recreation, scientific playground, and, yes, provider of materials.

The stone-and-water garden behind the World Forestry Center

You'll want to pick your time for a peaceful visit. School groups might be present, and if so, the screaming from the faux river-raft ride might be a little intense (take it from a former screamer). On the weekends, the center typically runs a canopy lift ride that takes you right up a tree and into the upper reaches of the great hall. And be sure to catch the stone-and-water garden out back.

Other exhibits cover forests of other countries, sustainability, and art (a rotating space has included photos by Ansel Adams). And yes, there's the tree-eating-monster game. I happen to be addicted to another ride, where you sit in a chair like you're para-chuting in to fight a fire, and you have to adjust for wind by pulling the chute's chords. I may or may not have done that a couple dozen times.

So next time you're up in Washington Park to walk among the trees or visit the zoo, start out with a little education and entertainment in the museum.

ᴗ̮ essentials

▭ 4033 SW Canyon Road, Portland, OR 97221

🕻 (503) 228-1367

🌍 worldforestry.org

$ Adults, $9; seniors age 62 and older, $8; children ages 3–18, $6; parking, $4; canopy ride, $4

🕐 Daily, 10 a.m.–5 p.m.

🚍 **MAX Light Rail:** Red or Blue Line to Washington Park

peaceful place 103

ZENANA SPA AND WELLNESS CENTER

Clinton, Southeast Portland (MAP 4)

CATEGORY ↙ shops & services ✪ ✪ ✪

A distinct vibe pervades Zenana, and it's one that initially made me feel like I needed to slow down and be nice. Not that I usually thrash around, or that anybody laid a trip on me there. But I am male and not a parent, and Zenana says

Comfort *and* coziness *are the watchwords at* Zenana *Spa and Wellness Center.*

that it's the "first day spa and wellness center in Oregon with a focus on pregnant and parenting families."

In fact, *zenana,* a Persian and Hindi word, refers to the room in the home where women gather and experiences are shared. That's the vibe I picked up on. The place is soothing, quiet, and nurturing, but also practical. In the gift shop near the entrance are rows of skin products and ergonomic baby carriers.

Waiting areas are filled with lush couches covered with pillows. One room has a wonderful beaded tapestry. There are massage spaces, a yoga space, and a room for foot treatments.

Then you look at the schedule and see prenatal yoga, yoga for moms and kids, child-birth education, and classes on breast-feeding, nutrition, and support for postpartum depression. Treatments include massage, full-body wraps, skin and back treatments, and stretch mark care and prevention.

I was reminded of a classic and typical story of a male friend when his first baby was born. He said that he drove home from the hospital at 10 mph with the hazards on and wanted to build a "cocoon of safety and comfort" for 10 feet around mother and child in every direction. He said he wanted to "bottle up all the love and comfort in the world and pour it all over them."

That's pretty much the vibe I got at Zenana. Try it.

⌣ essentials

✉	2024 SE Clinton Street, Portland, OR 97202
✆	(503) 238-6262
🌐	zenana-spa.com
$	$30–$515
🕐	**Boutique:** Daily, 9 a.m.–7 p.m. **Appointments:** Daily, 9 a.m.–8 p.m.
🚌	**TriMet Bus:** #4 to SE Division Street and 20th Avenue

𝒫aul Gerald started on newspaper sports desks because he wanted to get into the press box at football games. That led to various writing gigs at daily and weekly papers in California, Tennessee, and Texas. Eventually he branched out as a freelancer into the fields of travel, food, and the outdoors. He moved to Oregon in 1996 to pursue his writing habit and also to enjoy the ocean, mountains, rivers, and big trees. He can't seem to get enough hiking or camping, nor can he seem to stay in town when he has money—and no deadlines.

In addition to *Peaceful Places: Portland,* Gerald is the author of *60 Hikes within 60 Miles: Portland,* fourth edition (Menasha Ridge Press, 2010), and the revision author of *The Best in Tent Camping: Oregon,* second edition (Menasha Ridge Press, 2009). His other books include *Day & Section Hikes Pacific Crest Trail: Oregon,* second edition (Wilderness Press, 2012), and *Breakfast in Bridgetown: The Definitive Guide to Portland's Favorite Meal,* second edition (Bacon and Eggs Press, 2010).

photographed by Rachel Oliveri

Born in Berkeley, California, Gerald grew up in Memphis, Tennessee, and maintains family roots there. He contributes to the *Memphis Flyer* alternative newsweekly and, from his adult home, to *The Oregonian.*

The Overlook Trail affords a prime view of Mounts Rainier and St. Helens. (See Hoyt Arboretum, Peaceful Place 38, page 77.)